America THE Beautiful

CHICAGO

JORDAN WOREK

DAN LIEBMAN Series Editor

FIREFLY BOOKS

A FIREFLY BOOK

Published by Firefly Books Ltd. 2009

First printing

Publisher Cataloging-in-Publication Data (U.S.)

Worek, Jordan.
 Chicago / Jordan Worek.
[] p. : col. photos. ; cm. America the beautiful series.
Summary: A book of captioned photographs that showcase Chicago's natural wonders,
celebrated history and array of activities.
ISBN-13: 978-1-55407-543-0
ISBN-10: 1-55407-543-2
1. Chicago (Ill.) – Pictorial works. I. Title. II. Series.
977.311 dc22 F548.37.W674 2009

Library and Archives Canada Cataloguing in Publication

 Chicago / [captions written by] Jordan Worek.
(America the beautiful)
ISBN-13: 978-1-55407-543-0
ISBN-10: 1-55407-543-2
 1. Chicago (Ill.)--Pictorial works. I. Worek, Jordan II. Series: America
the beautiful (Richmond Hill, Ont.)
F548.37.C44 2009 977.3'110440222 C2009-901482-3

Published in the United States by
Firefly Books (U.S.) Inc.
P.O. Box 1338, Ellicott Station
Buffalo, New York 14205

Published in Canada by
Firefly Books Ltd.
66 Leek Crescent
Richmond Hill, Ontario L4B 1H1

Cover and interior design: Kimberley Young

Printed in China

The publisher gratefully acknowledges the financial support for our publishing program
by the Government of Canada through the Book Publishing Industry Development Program.

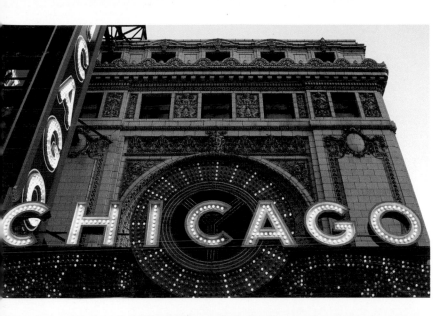

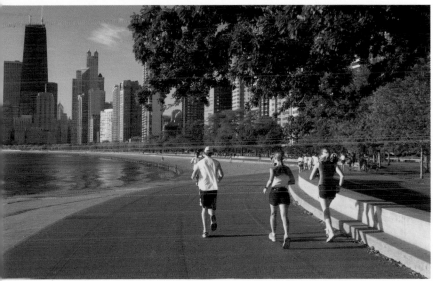

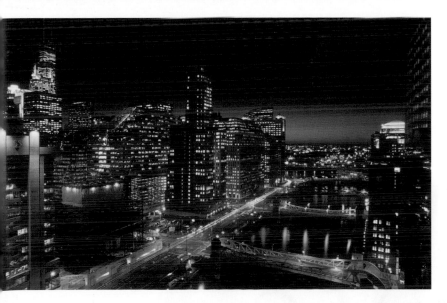

CHICAGO IS a city of architectural gems, vibrant neighborhoods, beloved sports teams, prestigious cultural institutions and outstanding attractions. The major metropolis of the American heartland, Chicago boasts a population of nearly three million people, making it the third most populous city in the country.

Founded in 1833, Chicago was known for its stockyards, steel mills and railroads when the Great Fire of 1871 destroyed most of the city. But a great building boom followed the fire, and today the city's skyline is among the world's most famous and most beautiful.

Popularly called the Windy City, Chicago is also known as the City of Big Shoulders. Its generosity of spirit has welcomed waves of newcomers and travelers, and the city is justifiably proud of its reputation as a friendly town. In the words of one song celebrating the city, "You'll lose the blues in Chicago."

Chicago is a patchwork of neighborhoods and, not surprisingly, a city of great food and regional specialties. It has a thriving downtown, providing an almost unlimited variety of things to do and see. The contemporary Millennium Park offers music, art and the Cloud Gate sculpture – nicknamed the Bean because of its shape – which lets visitors see their own reflection mirrored against the city's breathtaking skyline.

Chicago is a great sports town, too, where enthusiasts find professional teams of every major American sport. And there are renowned cultural institutions, a diverse and lively theater scene, the world-famous Navy Pier and other family attractions, the Magnificent Mile – and so much more.

But most of all, Chicago is a city of people. Some of them, including President Obama, are influential. All of them are extremely proud to be part of such a marvelous place.

From its soaring towers to its lakefront beaches, and from its diverse neighborhoods to its varied attractions, Chicago offers an abundance of treasures. We hope you'll enjoy them as you travel the pages of *America the Beautiful – Chicago.*

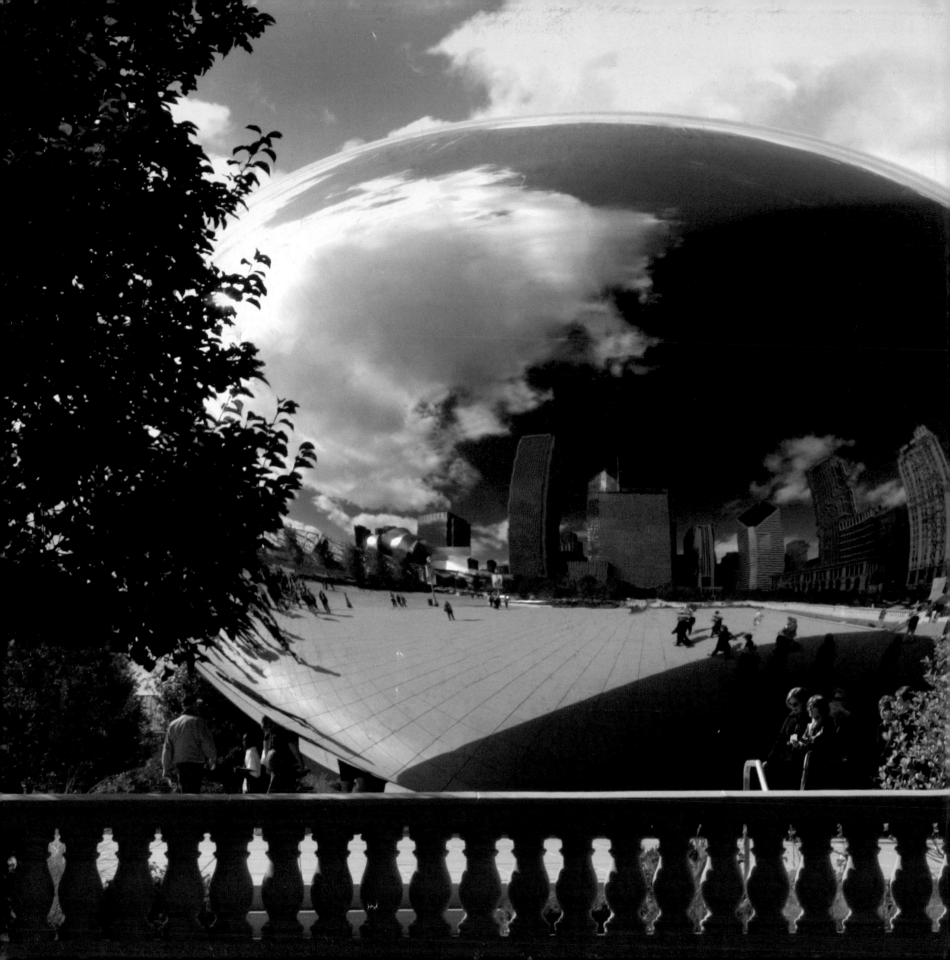

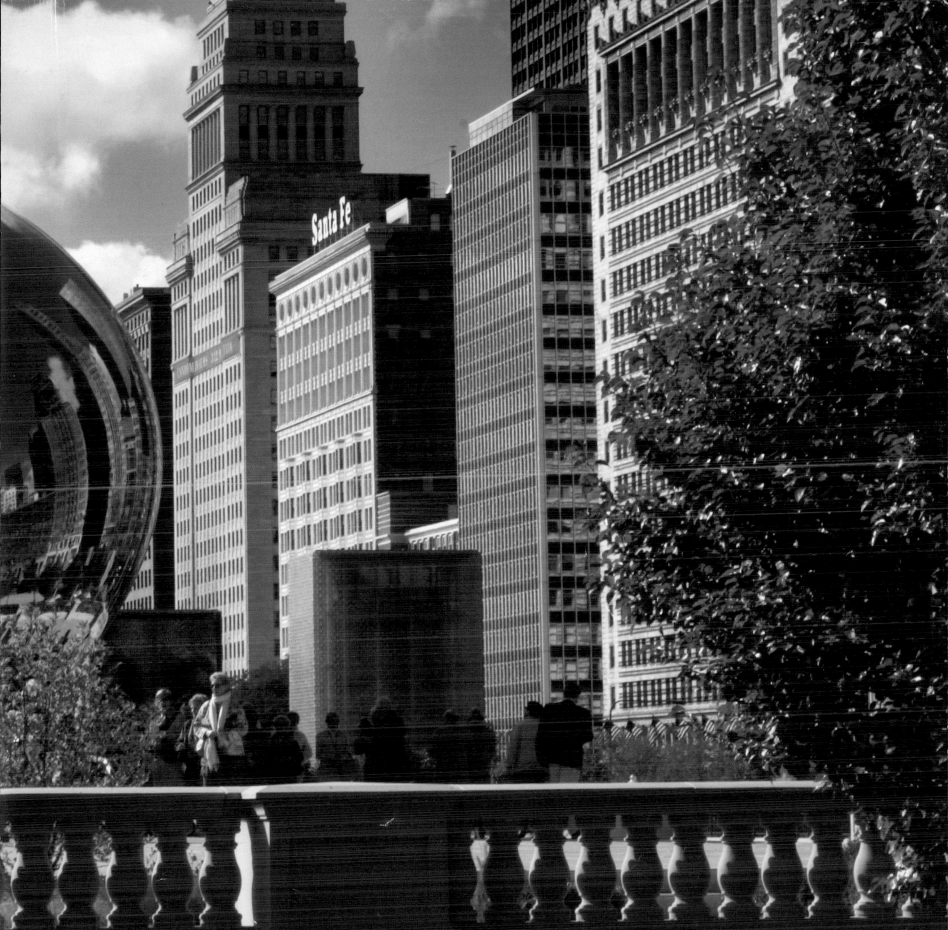

The Hancock Tower, the city's fourth tallest skyscraper, rises into the sky. An observatory and screened walkway allow people to experience the Windy City at 1,000 feet.

PREVIOUS PAGE: Cloud Gate, a public sculpture in Millennium Park's AT&T Plaza, became an instant landmark when unveiled in 2004. The sculpture, which was inspired by liquid mercury, was quickly nicknamed "the Bean" because of its shape. The city's skyline is reflected in "the Bean," a favorite location for photographers.

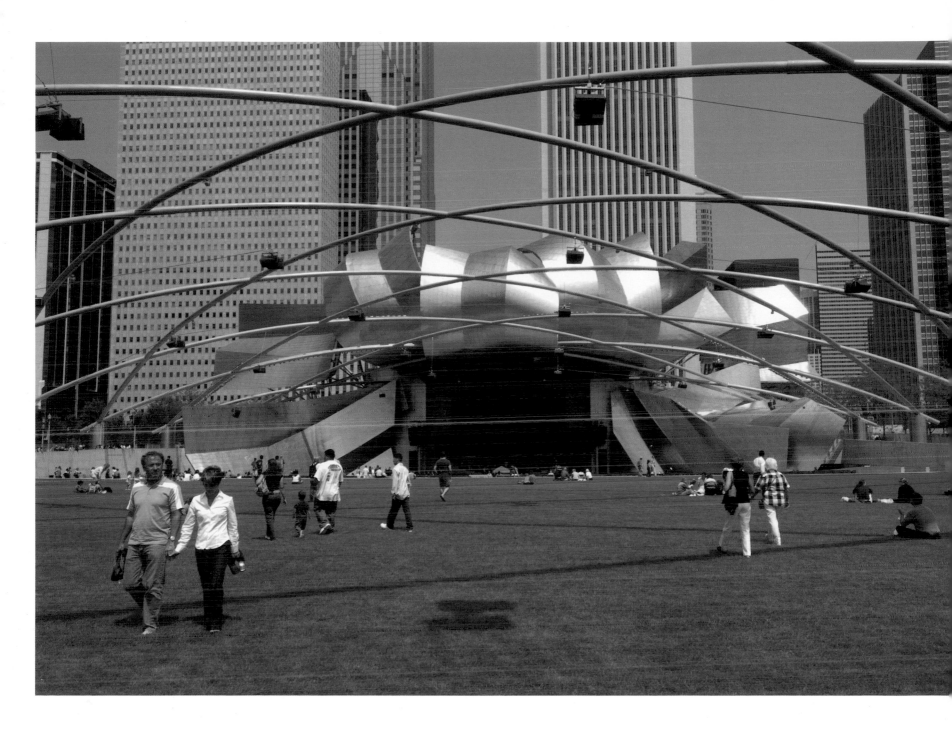

The futuristic Jay Pritzker Pavilion in Millennium Park, designed by Frank Gehry, hosts free concerts during the day and is brilliantly illuminated at night.

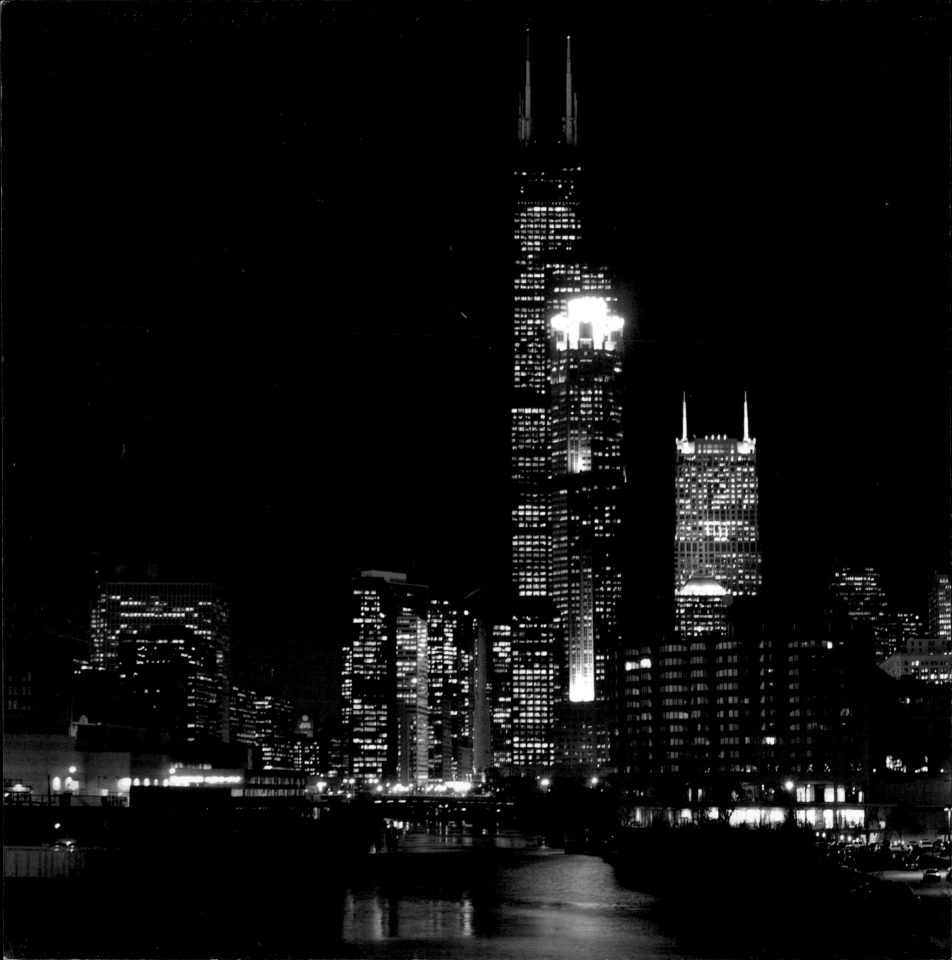

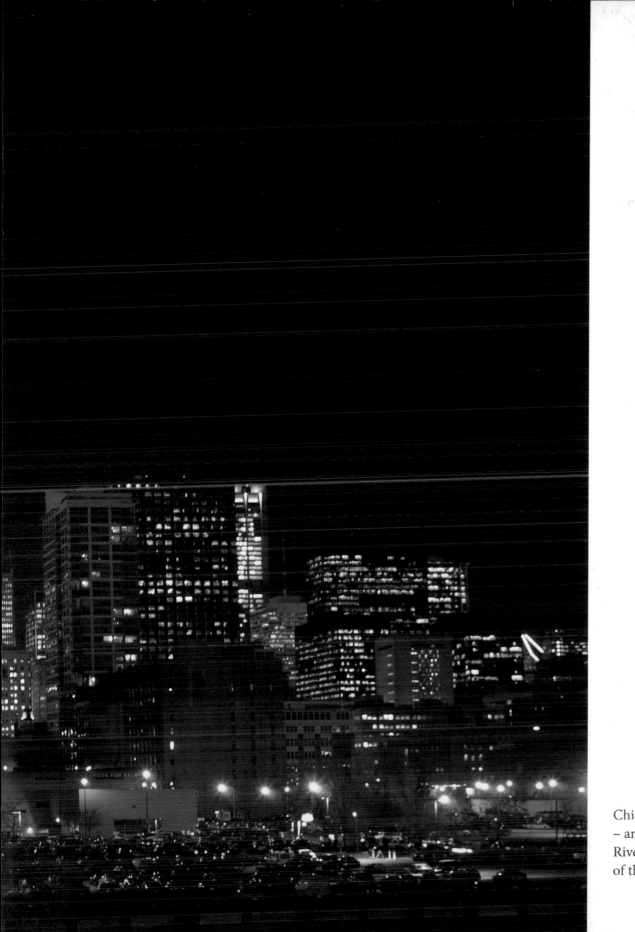

Chicago's skyline is one of the most famous
– and exciting – in the world. The Chicago
River has played a pivotal role in the growth
of the city since its inception.

RIGHT: Traders work feverishly in wheat futures at the Chicago Board of Trade, the world's oldest futures and options exchange.

The "Flamingo" sculpture standing in the Federal Plaza was created in 1973 by Alexander Calder. The piece stands 53 feet tall and weighs more than 50 tons.

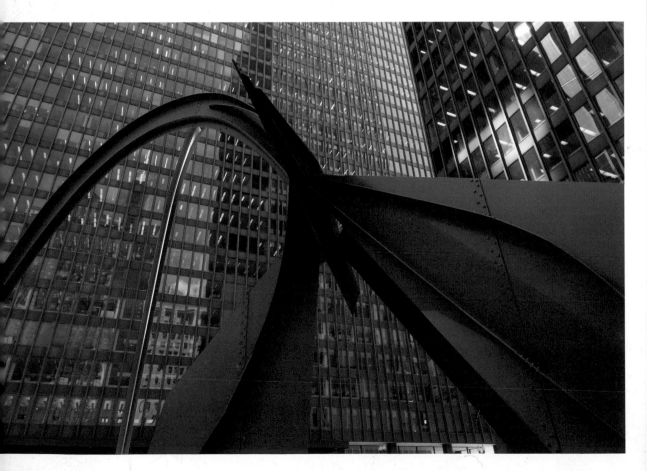

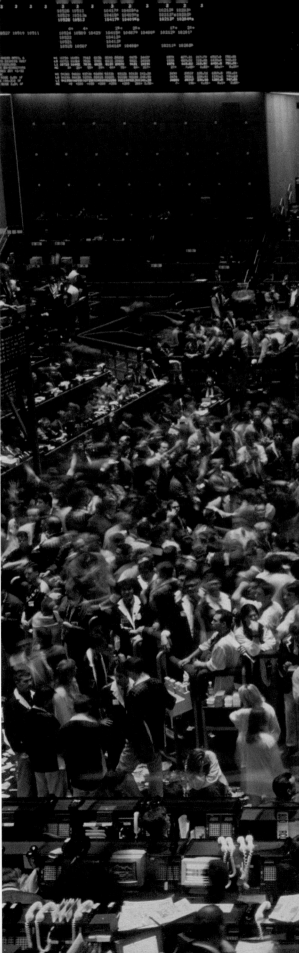

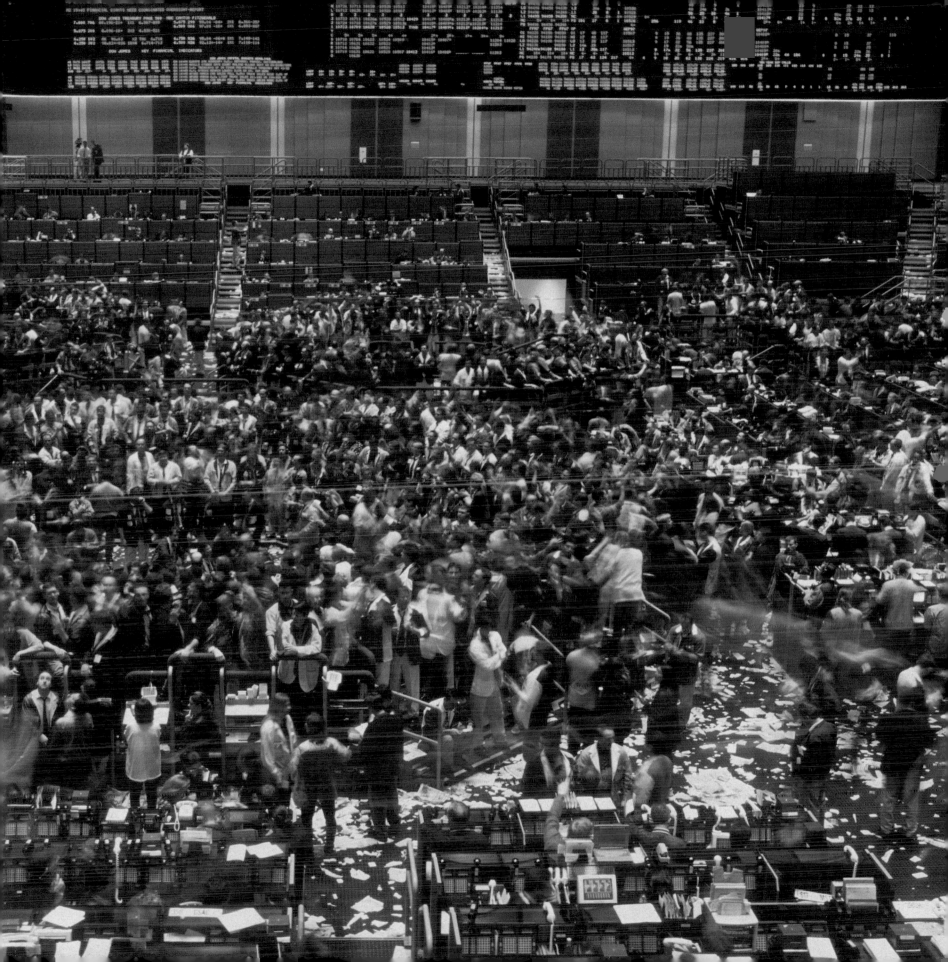

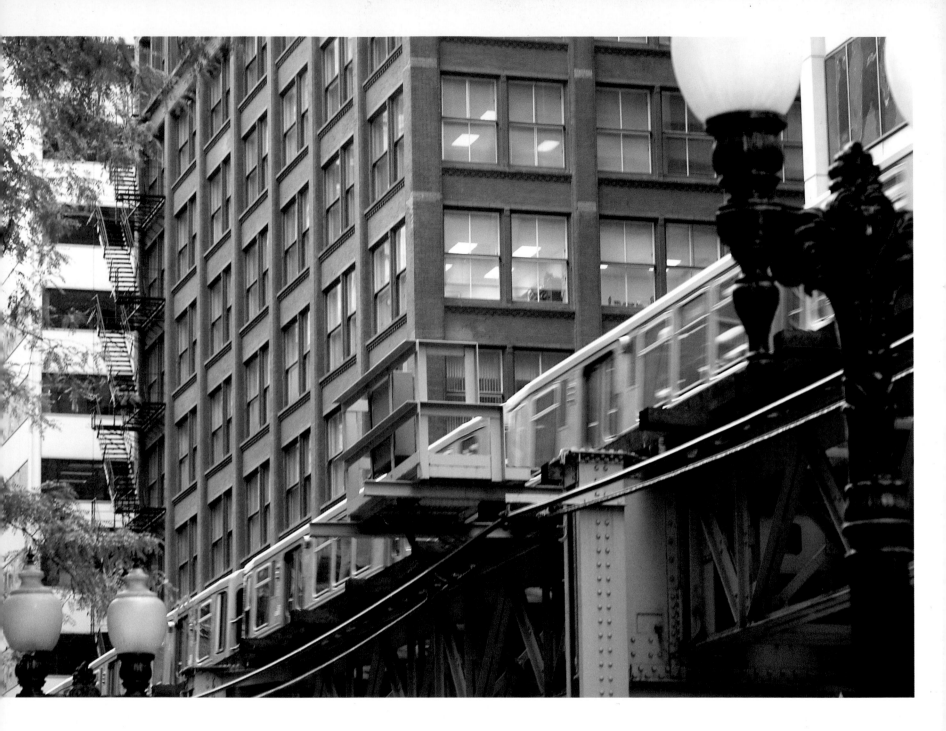

The Chicago "L" is the second oldest rapid transit system in the Americas and one of the few that offer 24-hour service. More than half of the 106.1 miles of transit line are elevated, as shown here.

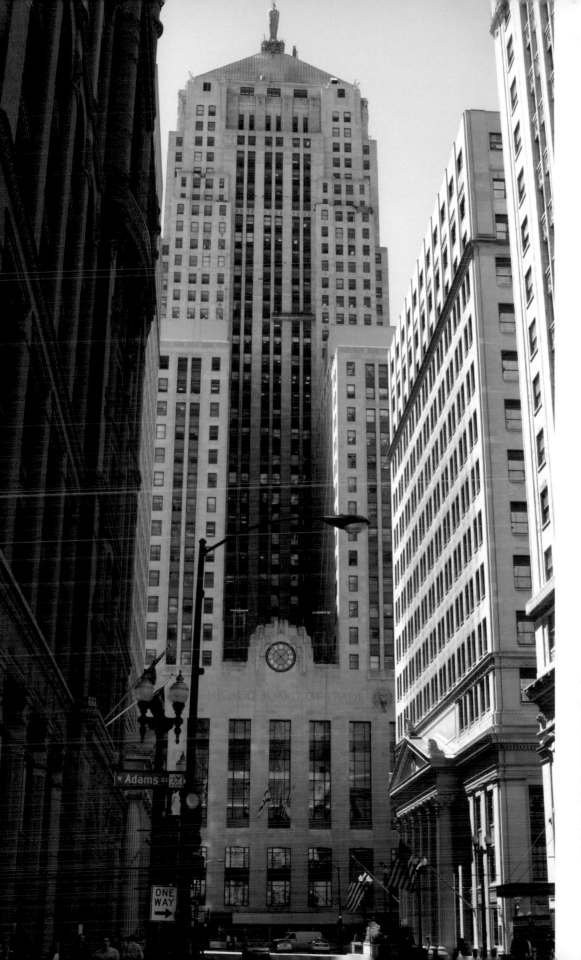

The Chicago Board Of Trade looms at the end of LaSalle Street, named after early Illinois explorer Sieur de la Salle. Established in 1848, its present building first opened its doors in 1930. The 45-story Art Deco structure was so much taller than any other building that, when first constructed, the sculpture of Ceres that adorns its top was left faceless because no one in surrounding buildings was high enough to see it.

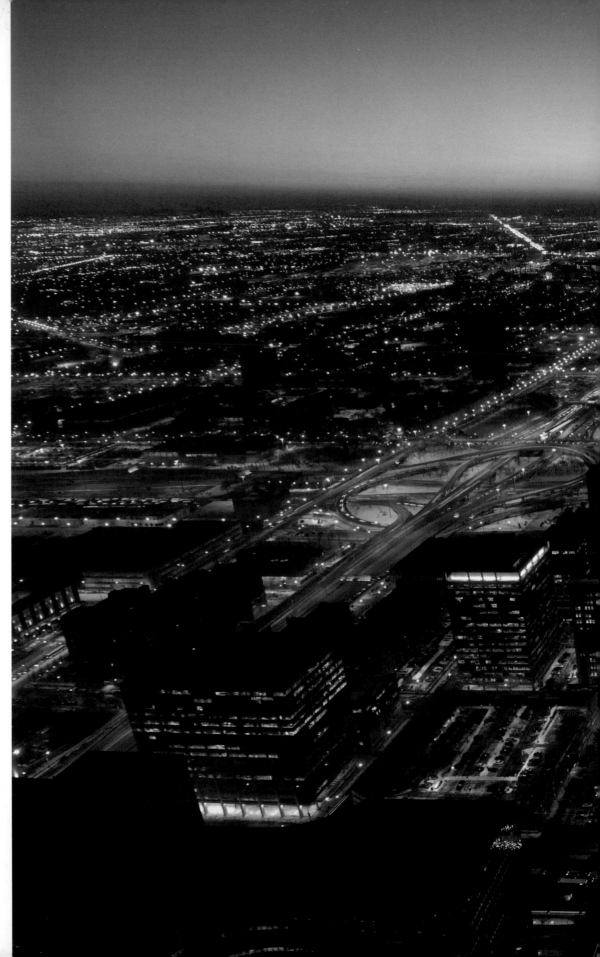

The view of the illuminated city at dusk from the celebrated Metropolitan Club on the 66th and 67th floors of the Willis Tower. The building was formerly known as the Sears Tower, and many locals continue to call it by that name.

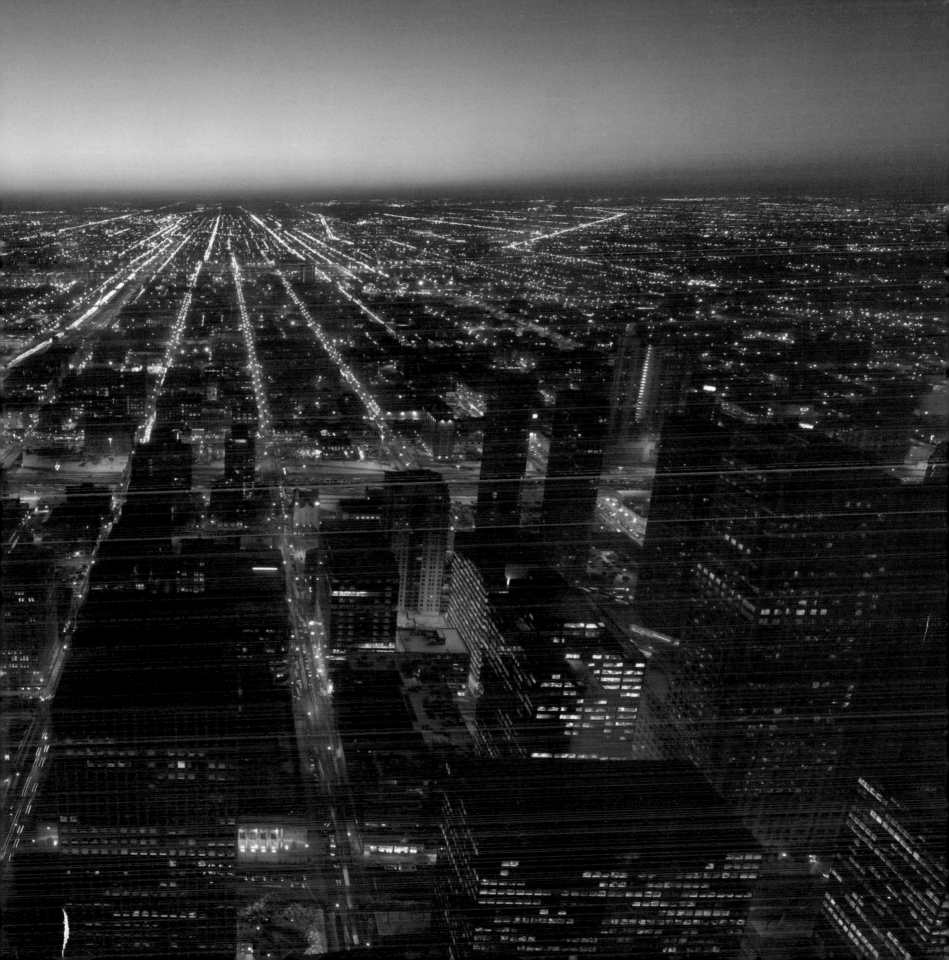

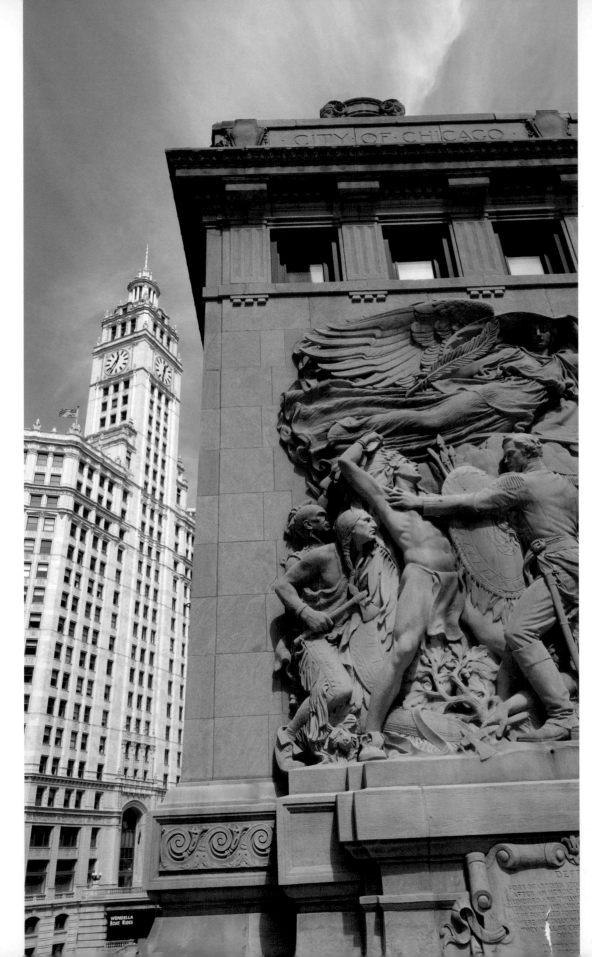

The Wrigley Building stands proudly behind the McCormick Tribune Bridgehouse & Chicago River Museum, located in the southewest bridge tower of the Michigan Avenue Bridge. Each marble bridge over the Chicago River has a similar building where the bridge tenders control the working of the bridge.

The Auditorium Theater was designed by Louis Sullivan and Dankmar Adler in 1889 and, although now designated a National Historic Landmark, continues to host regular music and dance performances.

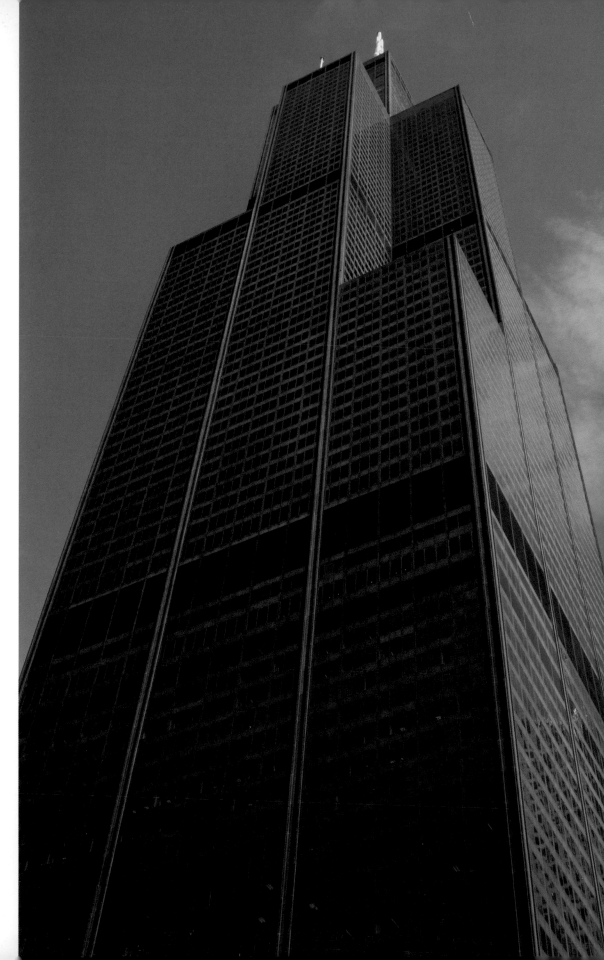

The Willis Tower was the world's tallest building from 1974 to 1998, when it was surpassed by the Petronas Twin Towers in Kuala Lumpur; the skydeck at 1,353 feet offers impressive views of the city on a clear day.

OPPOSITE PAGE: The James R. Thompson Center, completed in 1985 to mixed public opinion, features an exposed red steel frame and bright turquoise cladding.

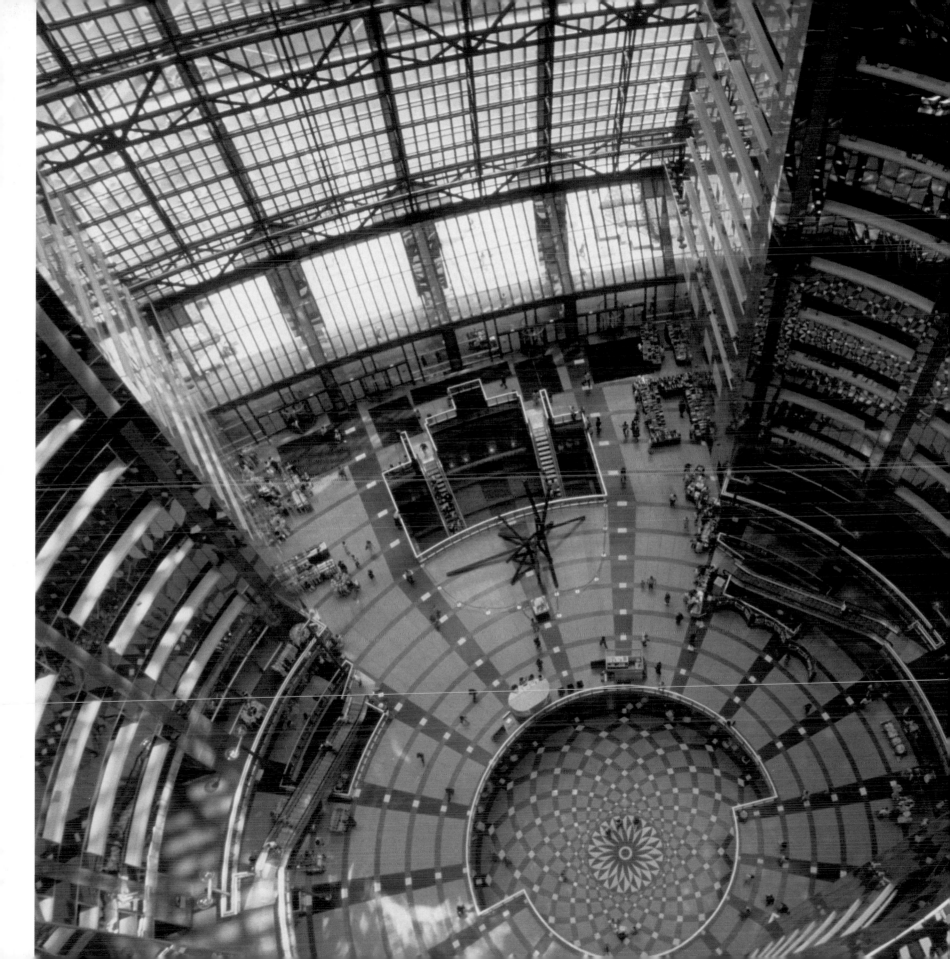

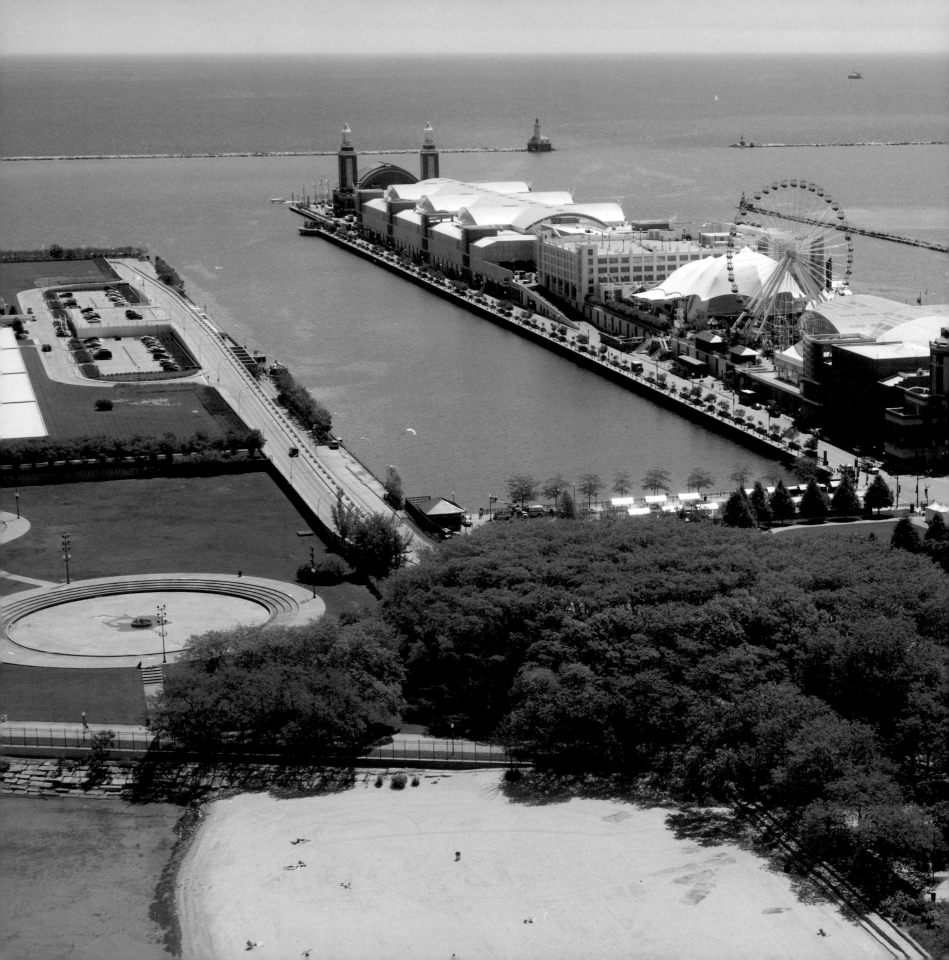

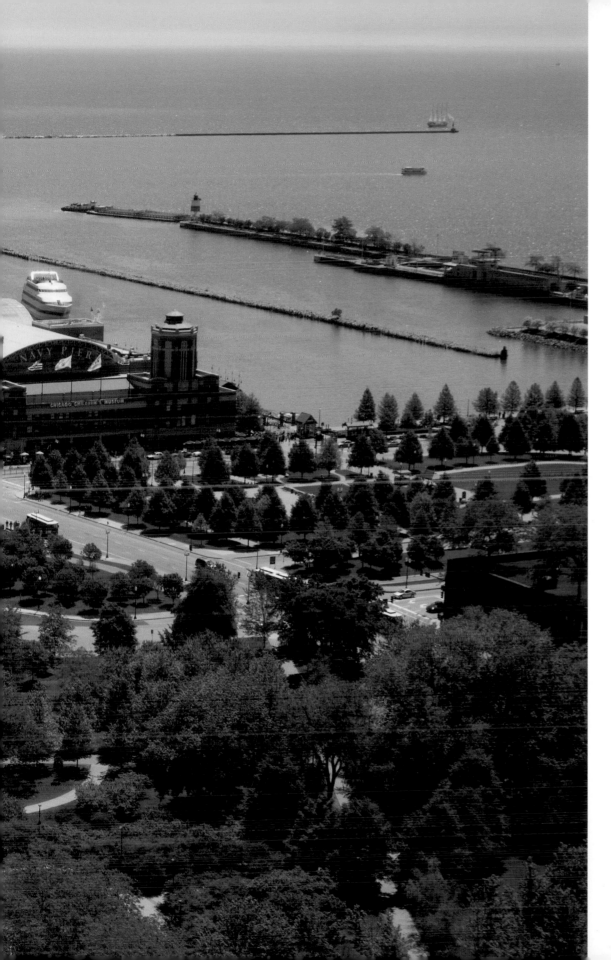

Olive Park beach is one of a number of small beaches scattered along Lake Michigan. Jutting into the lake is the 3,300-foot Navy Pier. The pier was built in 1916 and over the years has served as a cargo facility, a summer playground and, during World War II, a training center for Navy pilots. It was rebuilt in the 1990s, and today Navy Pier is one of the city's premier attractions.

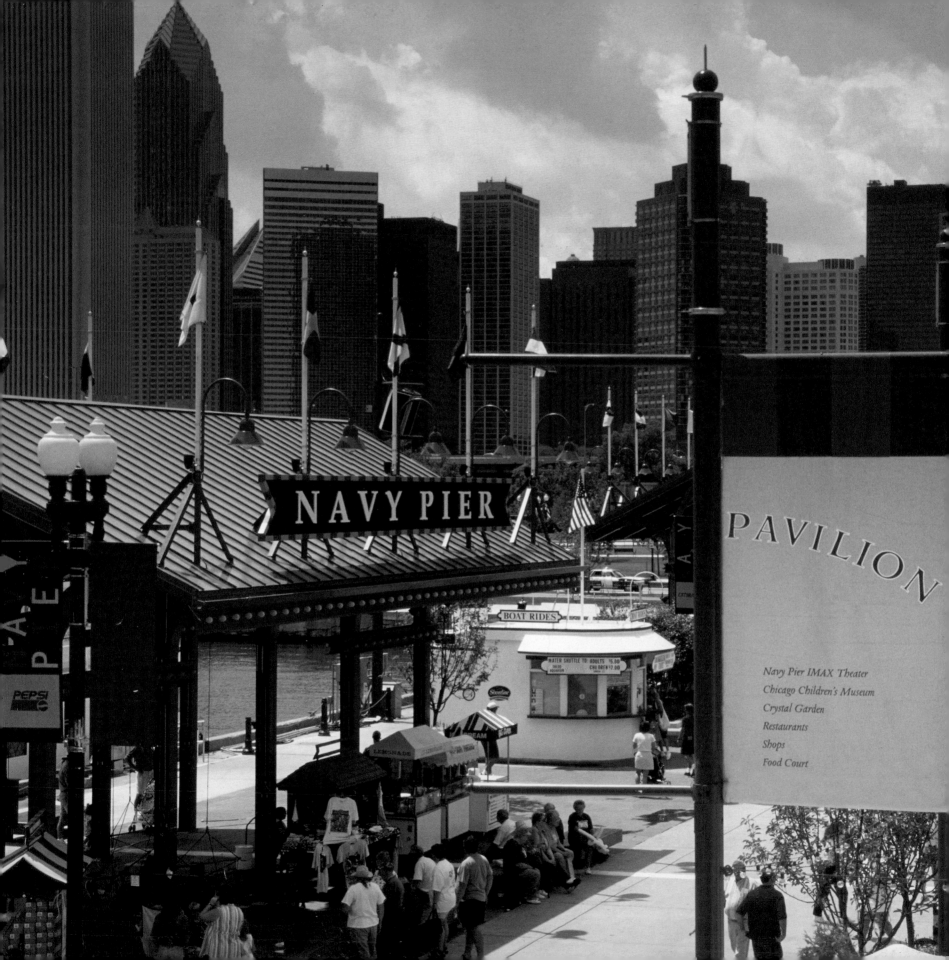

NAVY PIER

BOAT RIDES

WATER SHUTTLE TO: ADULTS $5.00 CHILDREN $2.00

PEPSI

PAVILION

Navy Pier IMAX Theater
Chicago Children's Museum
Crystal Garden
Restaurants
Shops
Food Court

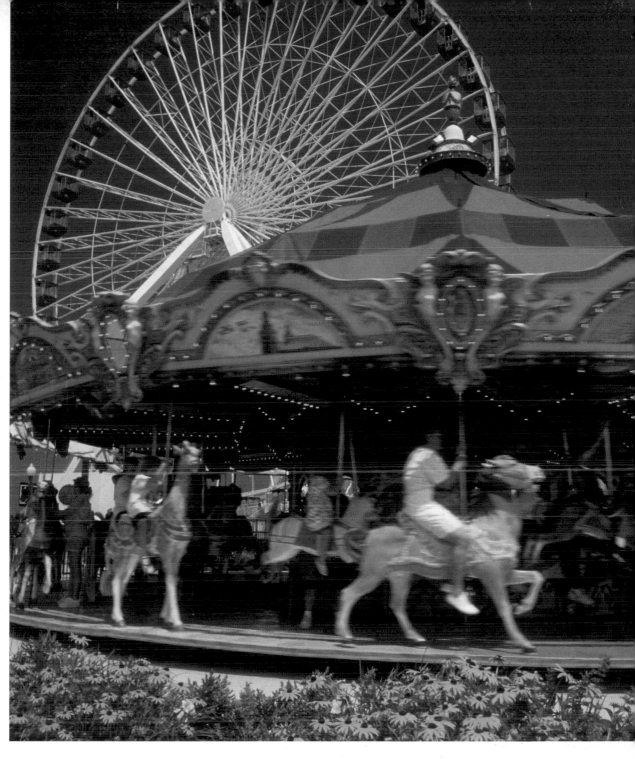

Navy Pier's most visible attraction is the 150-foot-high Ferris wheel, which provides unbeatable views of the city's skyline and lakefront. The musical carousel's hand-painted animals enthrall children of all ages.

OPPOSITE PAGE: The Museum of Science and Industry is one of the city's most popular attractions. The museum boasts more than 2,000 exhibits, many of them interactive, including a full-scale coal mine, Burlington Pioneer Zephyr train and 727 airplane.

The McCormick Tribune Campus Center is an architecturally significant addition to the Illinois Institute of Technology, located on the south side of Chicago. The single-story building was designed by famed architect Rem Koolhaas.

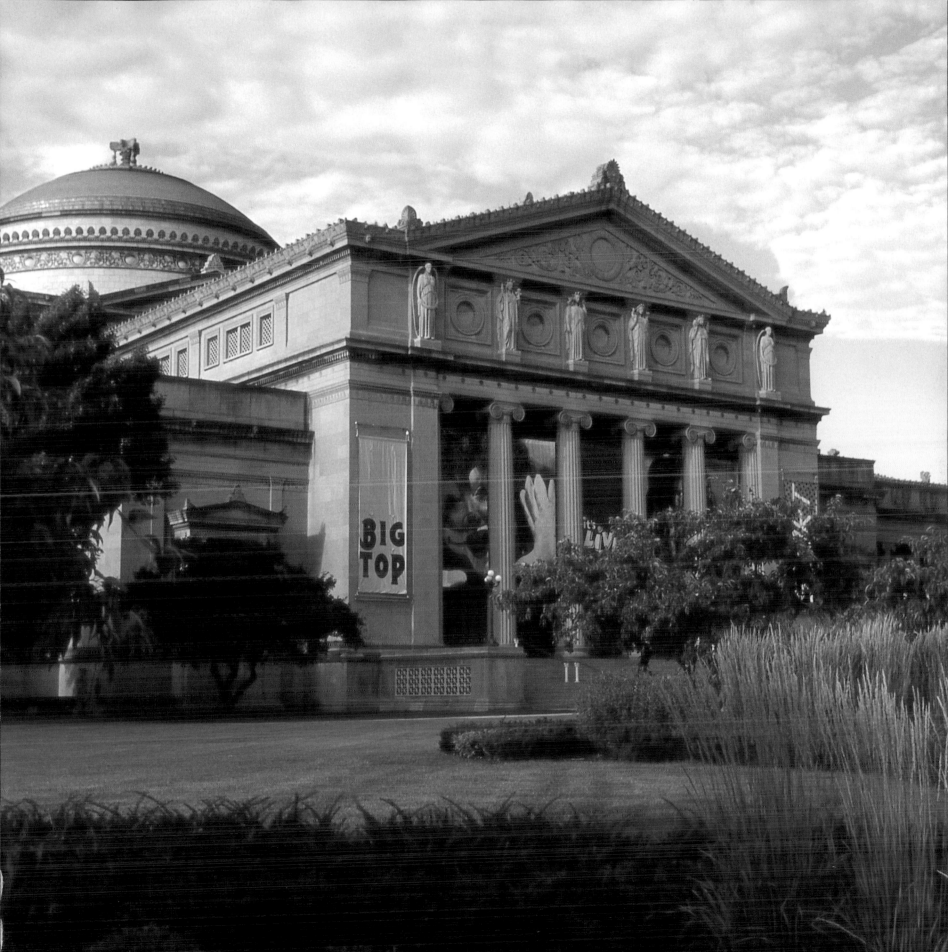

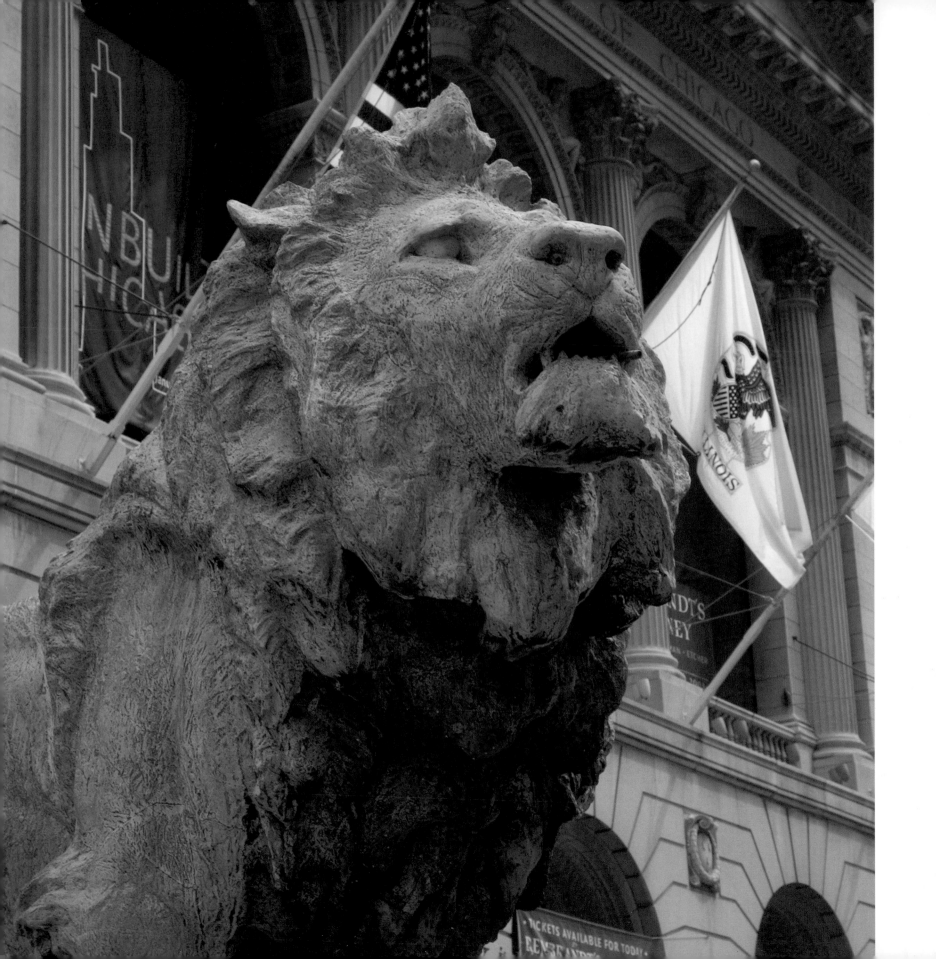

OPPOSITE PAGE: This lion – one of a famous pair – stands guard at the Art Institute of Chicago, the oldest sections of which were built in 1893 as part of the World's Columbian Exposition. The museum boasts treasures in every imaginable medium from the ancient world to the present day.

The new modern wing of the Art Institute of Chicago opened in May 2009 and will provide a proper home for a much wider selection of its 20th- and 21st-century art.

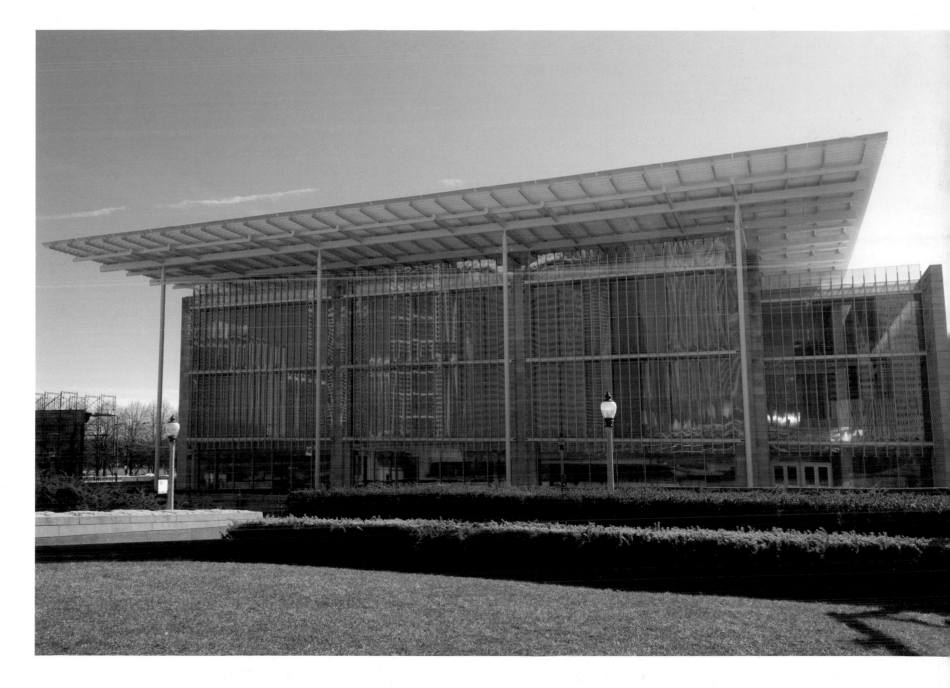

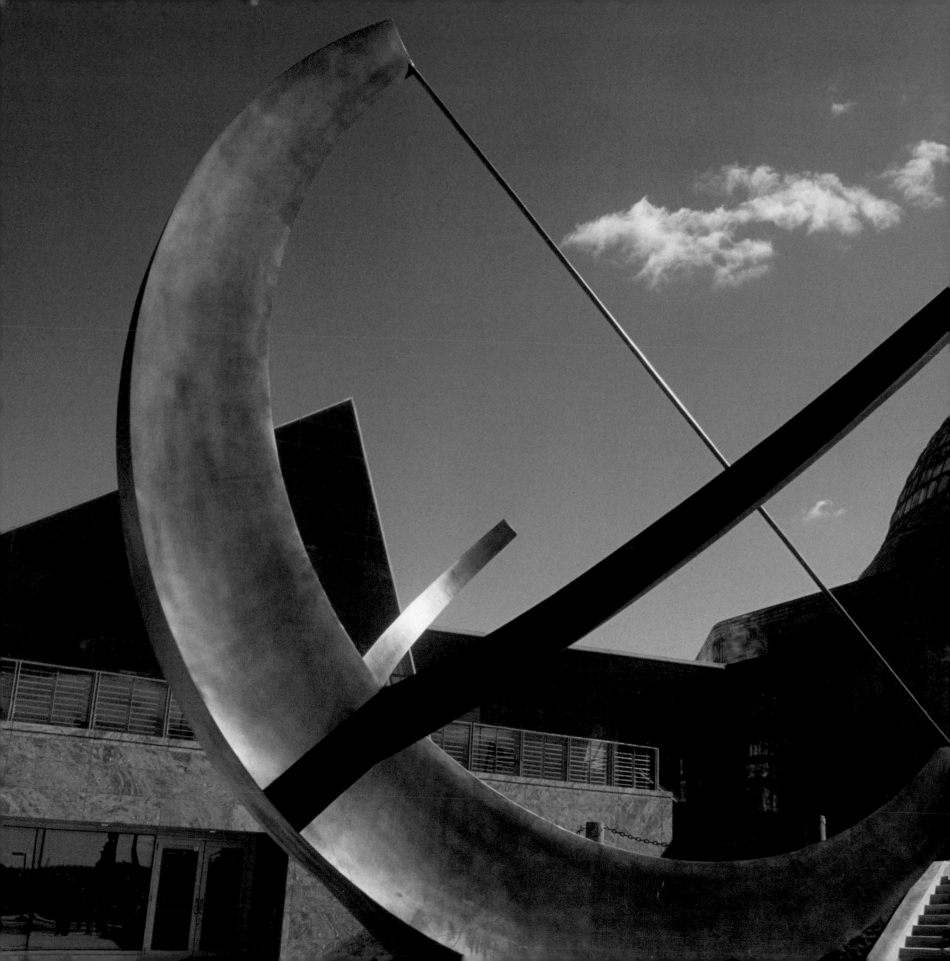

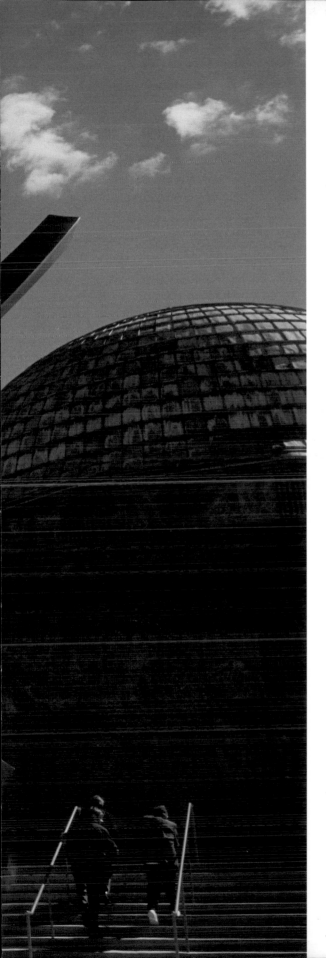

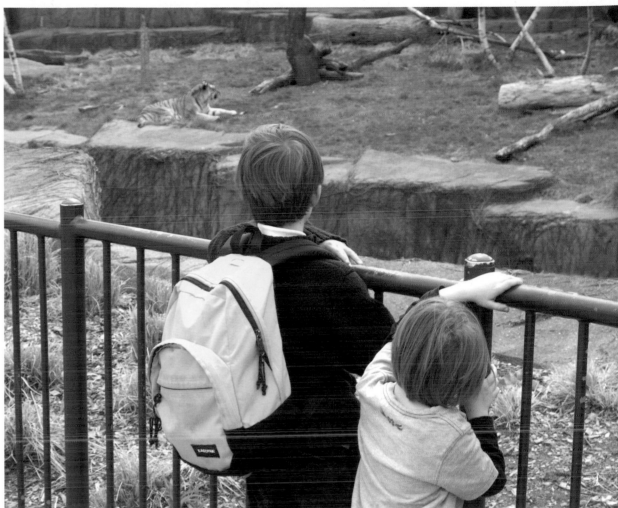

Schoolchildren observe the lions at Lincoln Park Zoo. The zoo was founded in 1868 with a pair of swans, and it has since grown to more than 1,250 animals comfortably sheltered within a short distance of Chicago's skyscrapers.

LEFT: The Adler Planetarium was the first of its kind in the Western Hemisphere and declared a National Historic Landmark in 1987. It has nevertheless adapted to the 21st century and now boasts virtual reality programs and 3D theaters.

OPPOSITE PAGE: One of the Field Museum's most famous exhibits is *Sue*, the largest and most complete fossil of a *Tyrannosaurus rex* ever found; it was acquired in 1990 for a hefty $8.4 million. *Sue* measures 13 feet at the hips and is 42 feet long from head to tail.

The Field Museum of Natural History was incorporated in 1893 with the mission of "accumulation and dissemination of knowledge, and the preservation and exhibition of objects illustrating art, archeology, science and history." The Field Museum hosts some of the best permanent and traveling exhibits in the country.

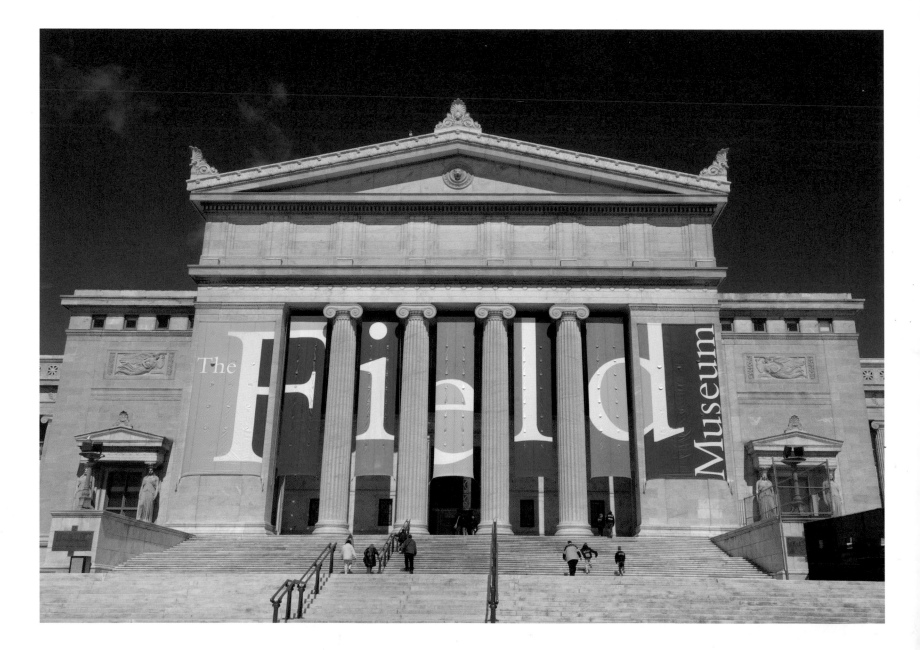

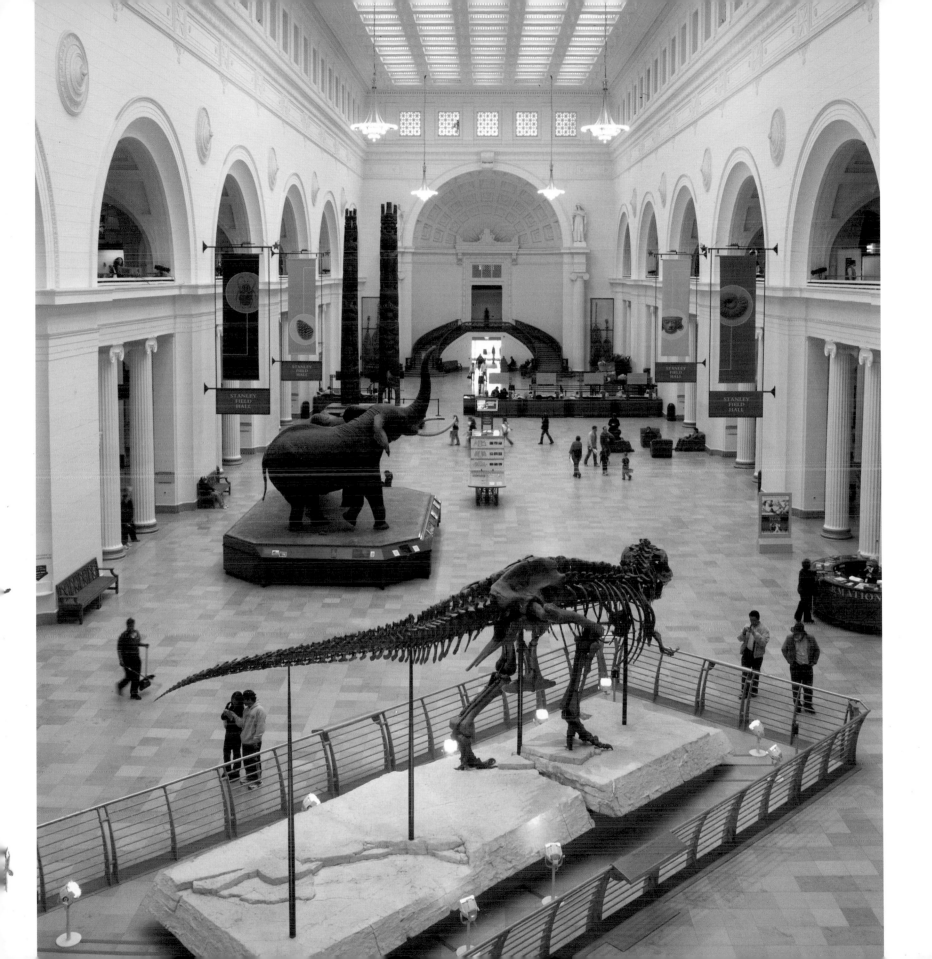

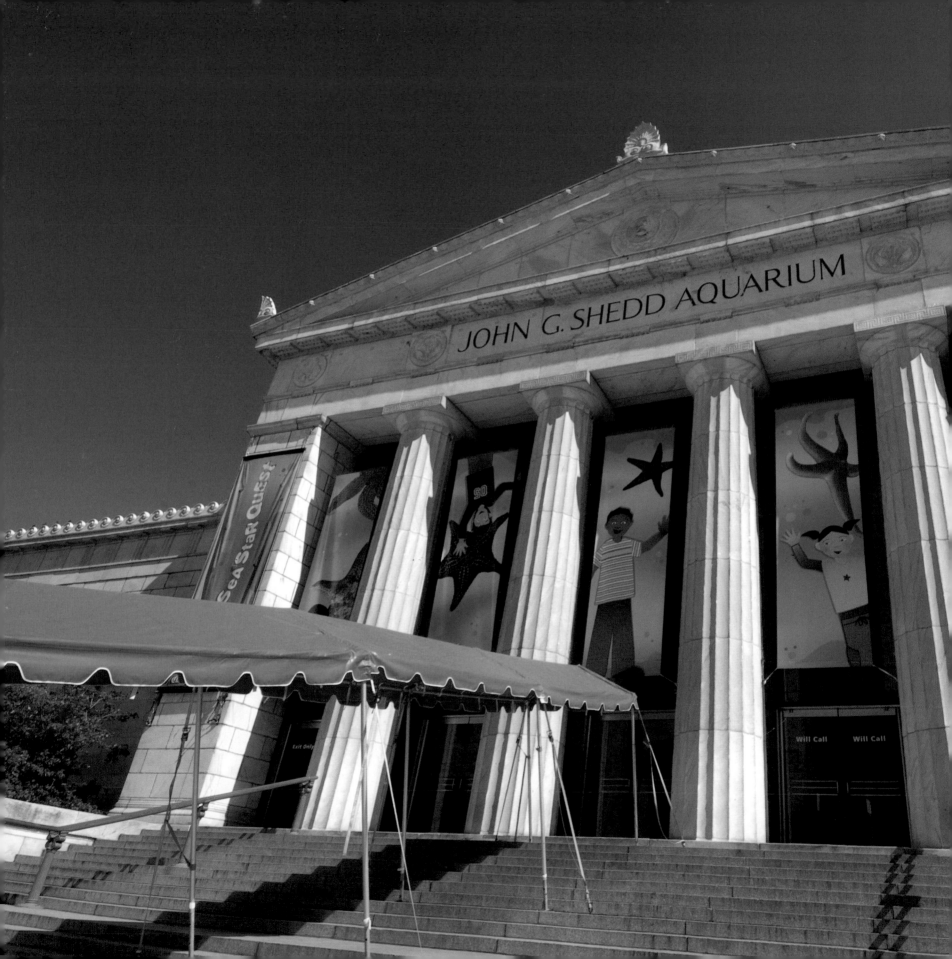

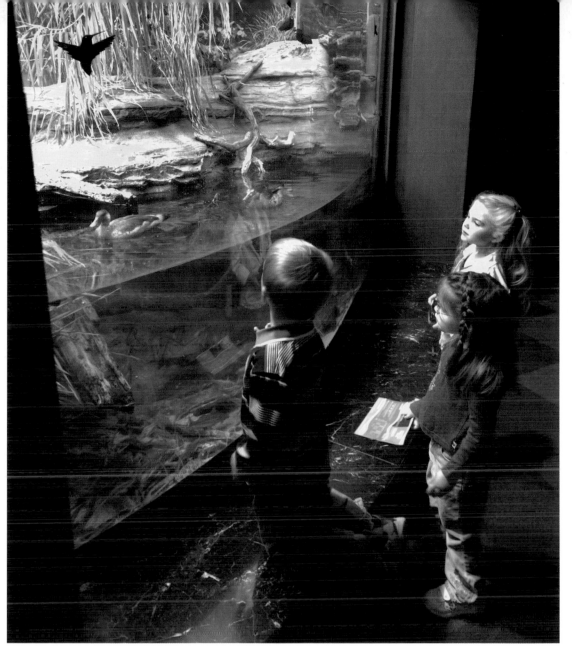

The John G. Shedd Aquarium has more than 32,000 living creatures in their habitats to observe and interact with; it also puts a strong emphasis on education and research.

LEFT: The John G. Shedd Aquarium is one of the world's largest. Thousands of sea, lake and river creatures thrive within the marble octagon perched on the edge of Lake Michigan. Some of the more dynamic habitats include the 90,000-gallon Caribbean Coral Reef and the *Oceanarium*, which replicates a Pacific Northwestern environment.

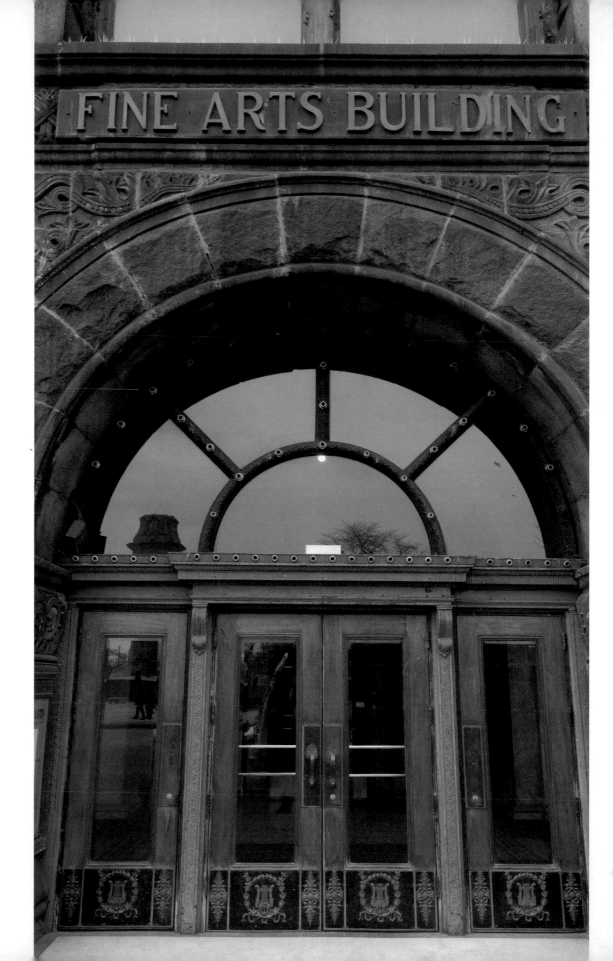

The ornate portal to the Fine Arts Building, a self-described haven for artists since 1898. It is one of the few remaining structures in the city specifically built to shelter working artists.

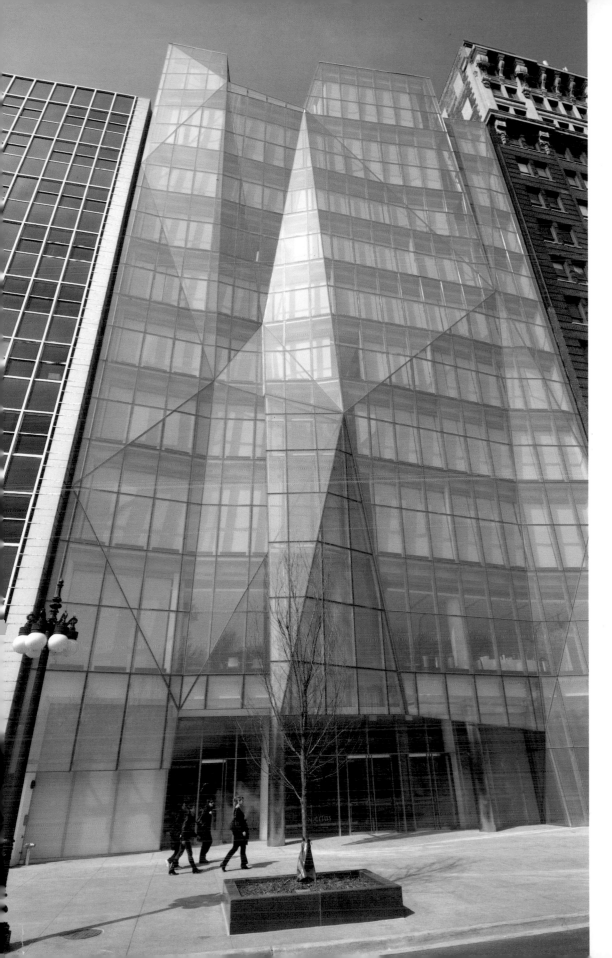

The exterior of the Spertus Institute of Jewish Studies is made up of 726 windows in 556 different shapes. The structure sits on Michigan Avenue, directly facing Grant Park.

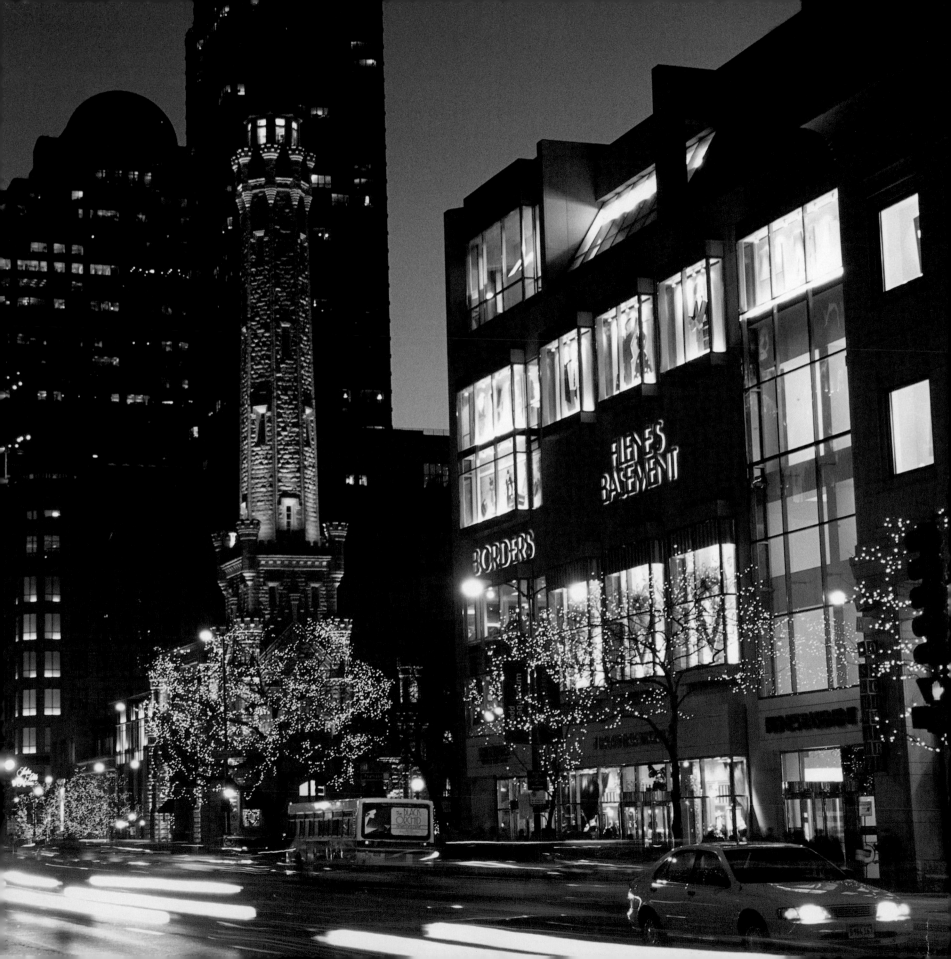

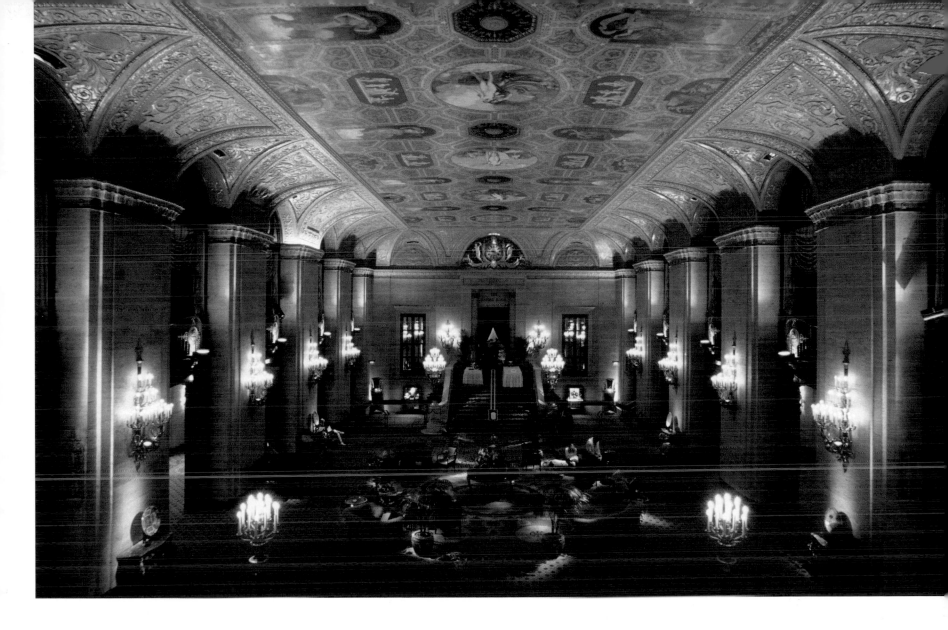

The Palmer House Hilton, built between 1925 and 1927, is a Chicago landmark and remains one of the city's finest hotels. Architectural features include a marble-clad double staircase and two ballrooms.

OPPOSITE PAGE: Michigan Avenue is the home of some of the city's top attractions, including the Art Institute of Chicago, Millennium Park and the Magnificent Mile. The Water Tower, located along the "Mag Mile," survived the Great Chicago Fire.

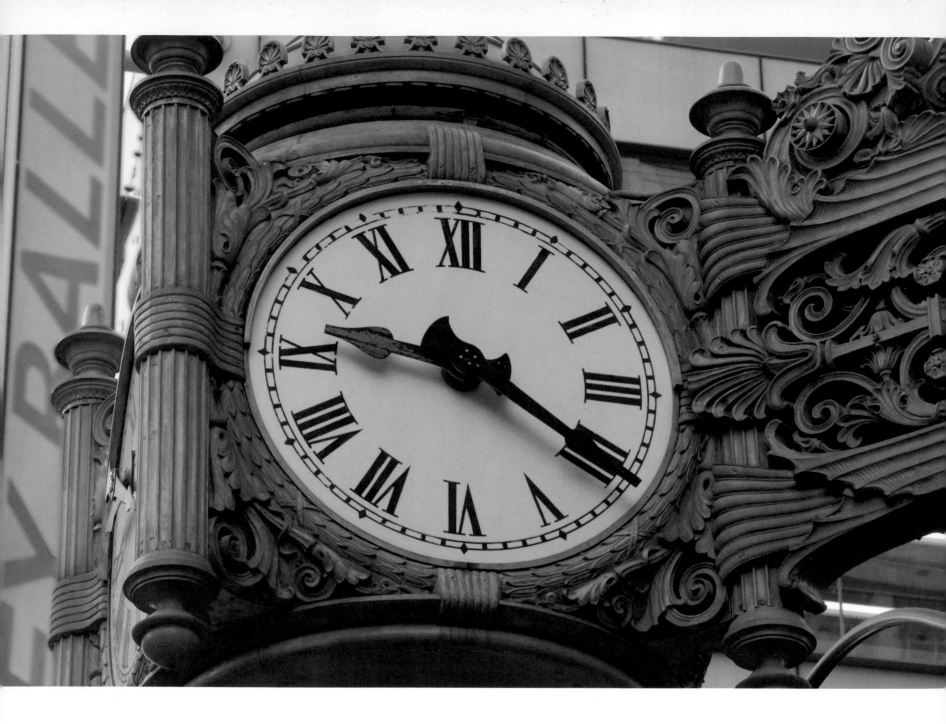

Two of Macy's most distinguishing features are its seven-ton bronze clocks that hang 17 feet above the sidewalk; the first was installed in 1897 and the other a decade later.

OPPOSITE PAGE: The former flagship Marshall Field and Company Building on State Street in the Loop became Macy's in 2006. Designated a National Historic Site in 1979, it takes up an entire city block and has more than two million square feet of retail space.

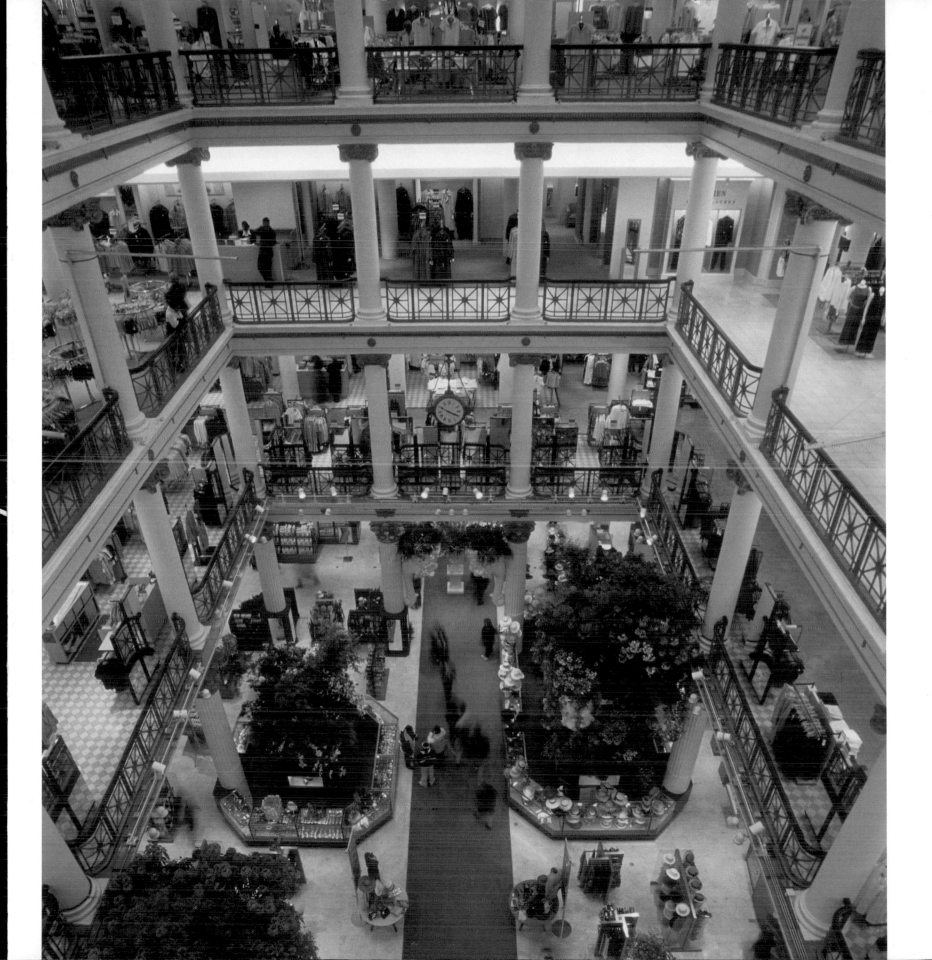

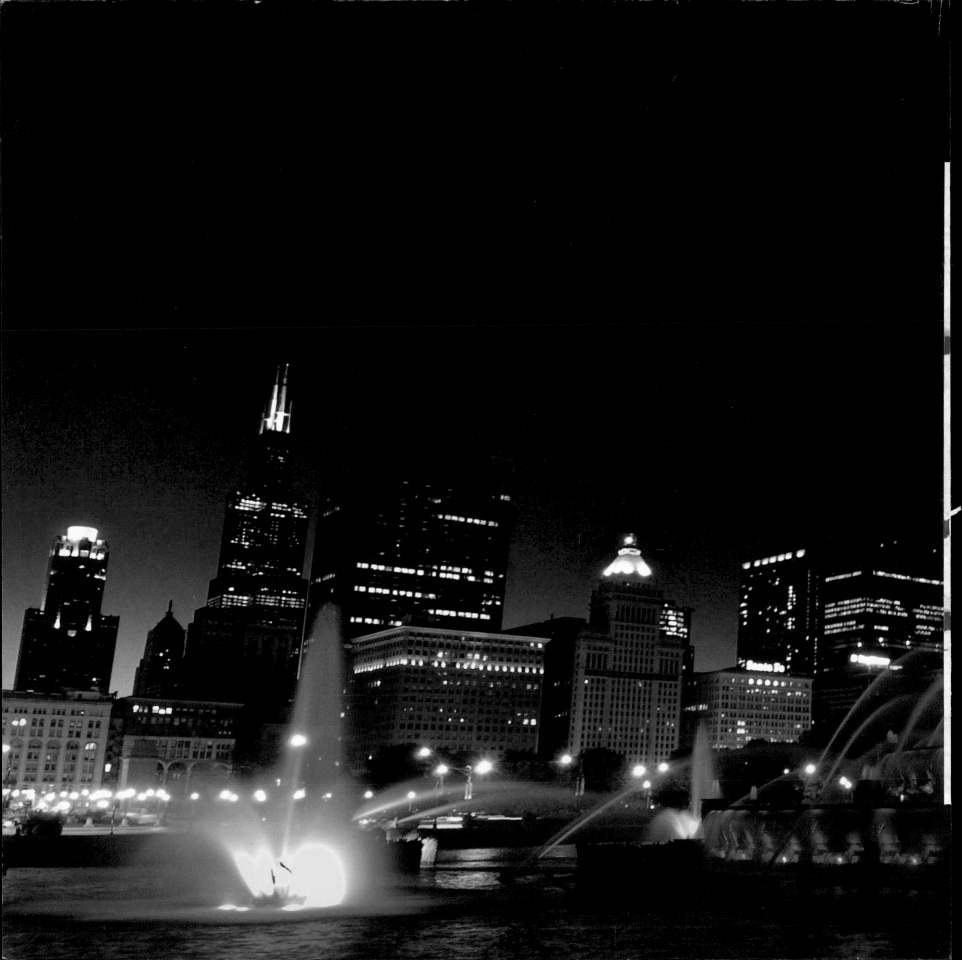

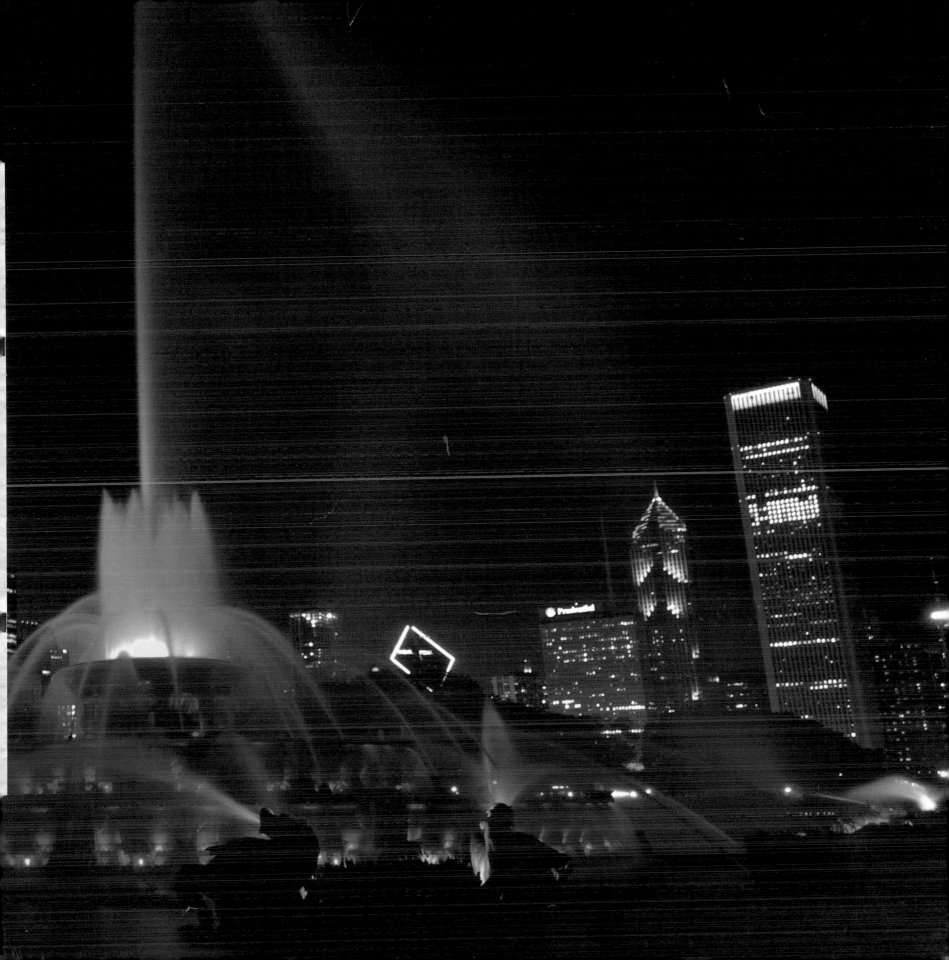

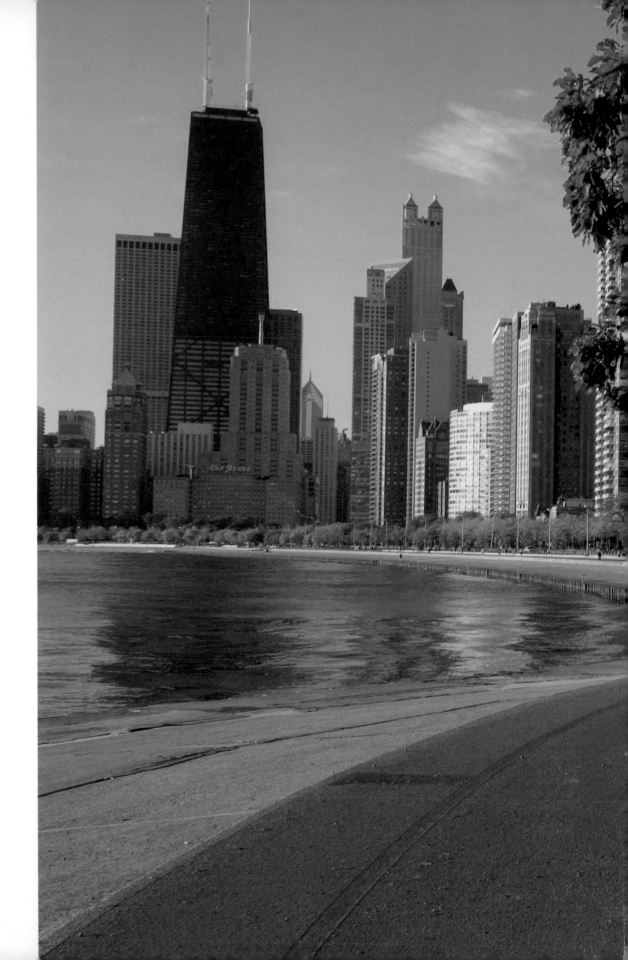

Joggers enjoy the lakefront path that extends more than 18 miles along the shore of Lake Michigan.

PREVIOUS PAGE: Buckingham Fountain, the Baroque centerpiece of Grant Park, is modeled after the Latona Fountain at Versailles but is twice its size. Water spurts 150 feet in the air every hour on the hour, from April through October.

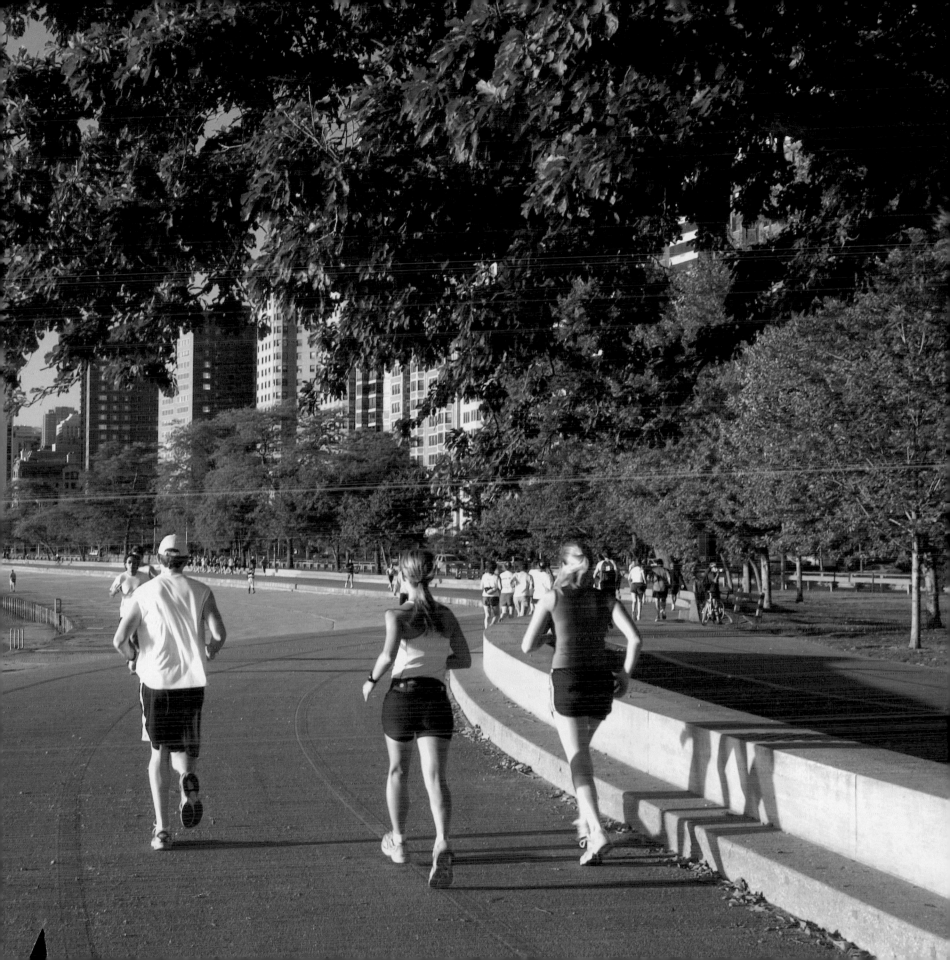

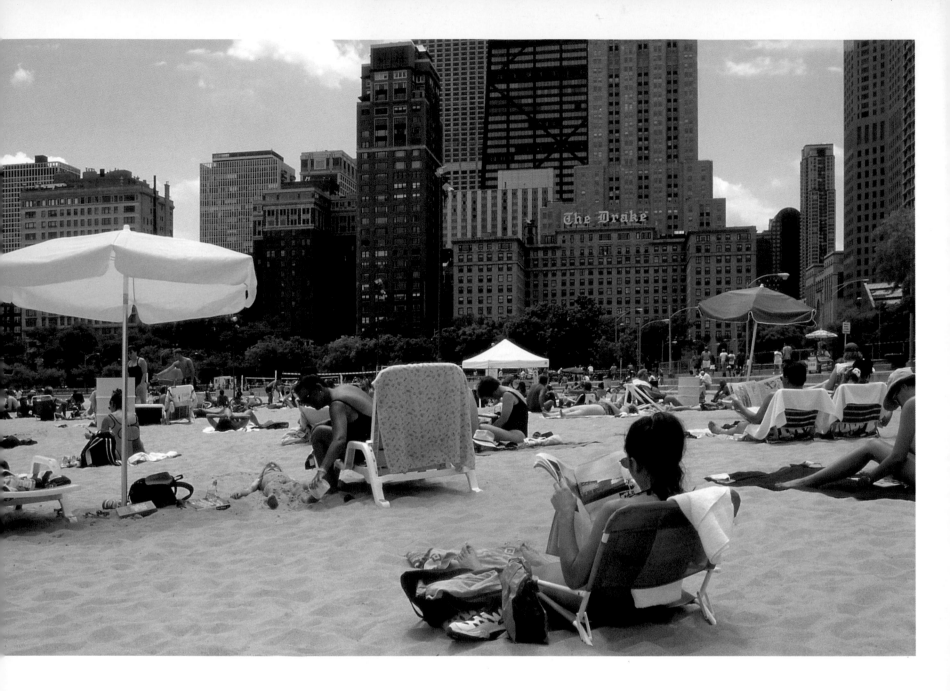

The convergence of city and lakeshore is striking at Oak Street Beach, a popular and convenient place to enjoy the summer weather.

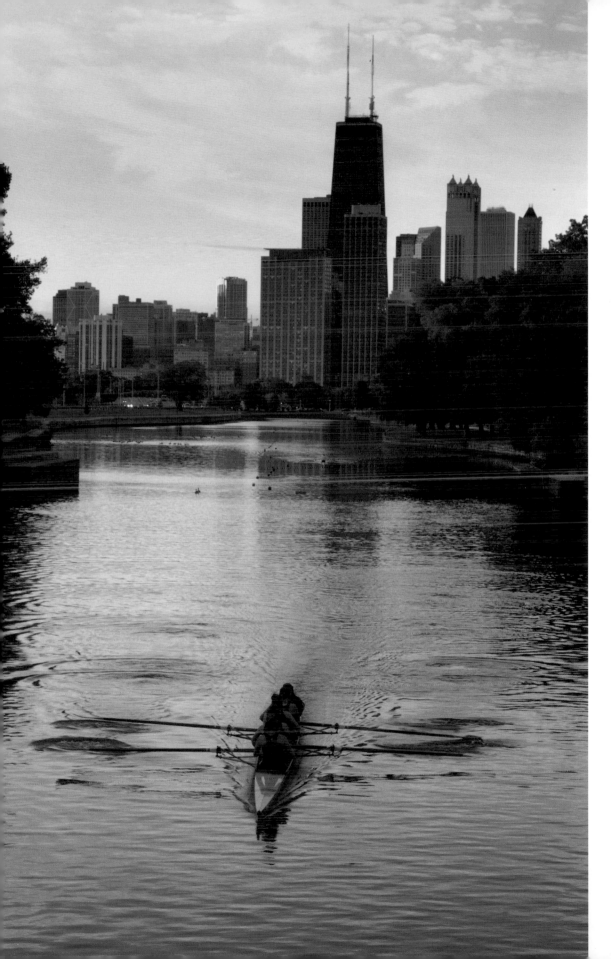

A crew team rows in Lincoln Park with the city skyline before them. The Lincoln Park Boat Club was founded in 1910.

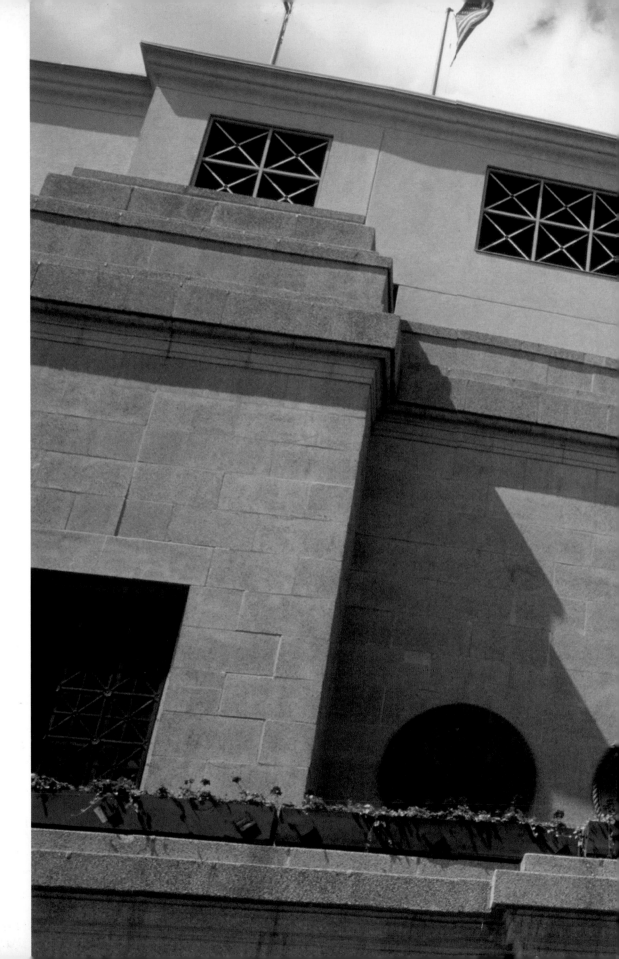

Soldier Field, home of the Chicago Bears football team, can accommodate more than 60,000 fans. The historic stadium reopened in 2003 after a major rebuilding project.

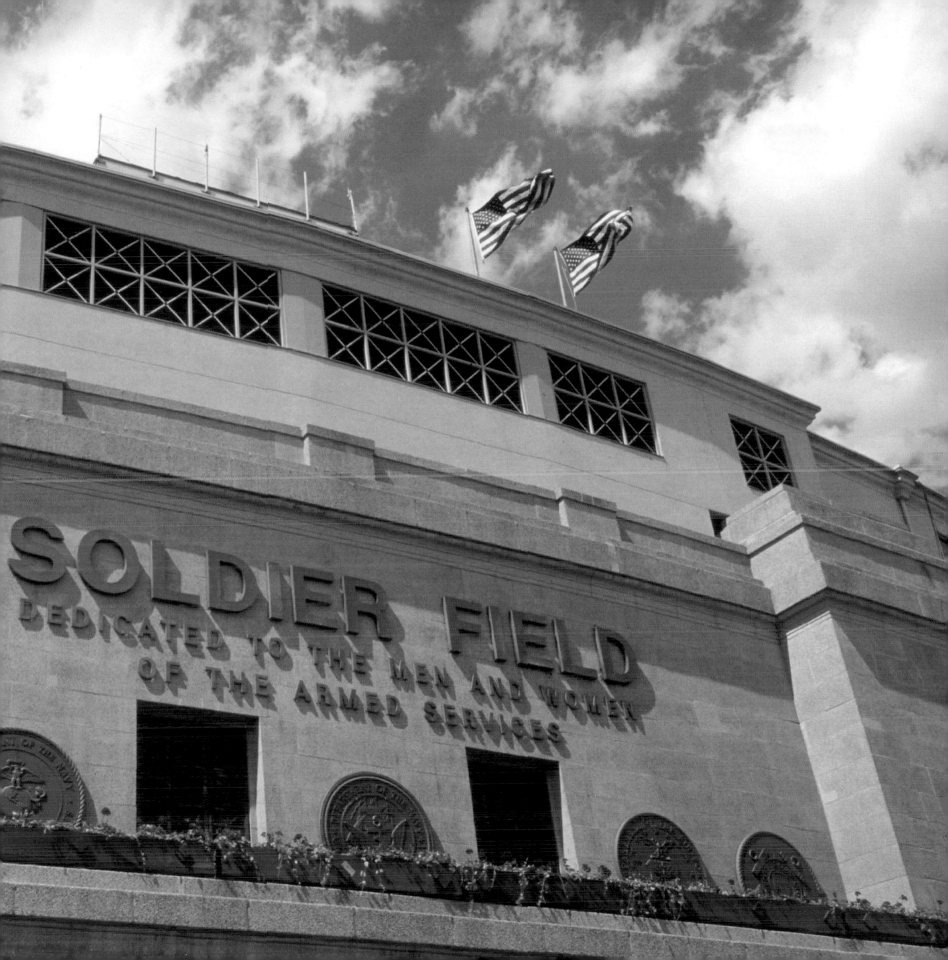

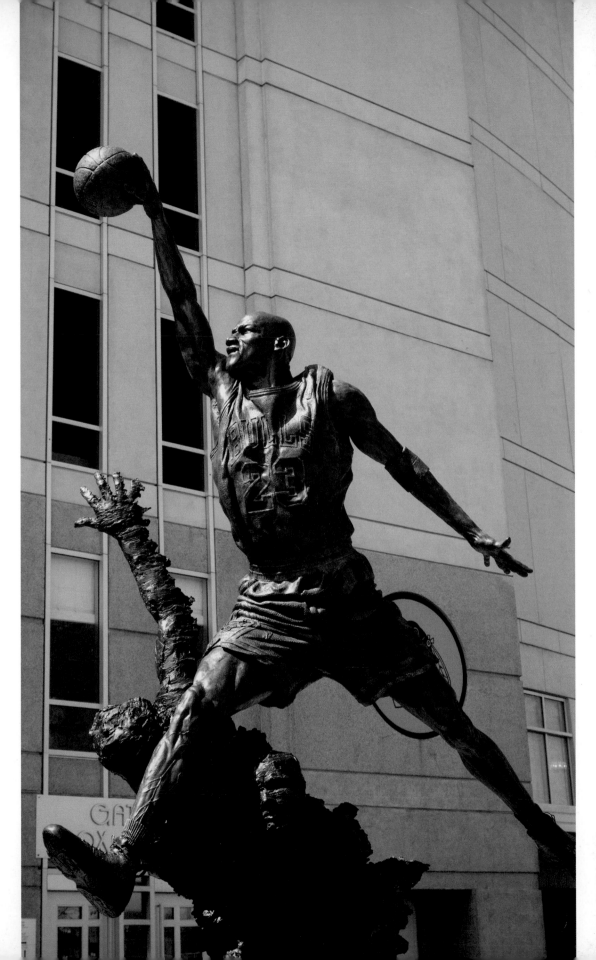

This 12-foot-tall bronze statue of Hall of Fame basketball legend Michael Jordan was unveiled in 1994 and stands at the entrance to the United Center. The largest arena in the nation (by total area), it is the home of the Chicago Bulls and the Chicago Blackhawks.

OPPOSITE PAGE: Wrigley Field has served as the home of the Chicago Cubs since 1916 and is the oldest National League ballpark. Nicknamed the "Friendly Confines," Wrigley can be either friendly or unfriendly to pitchers. It all depends on the way the wind blows.

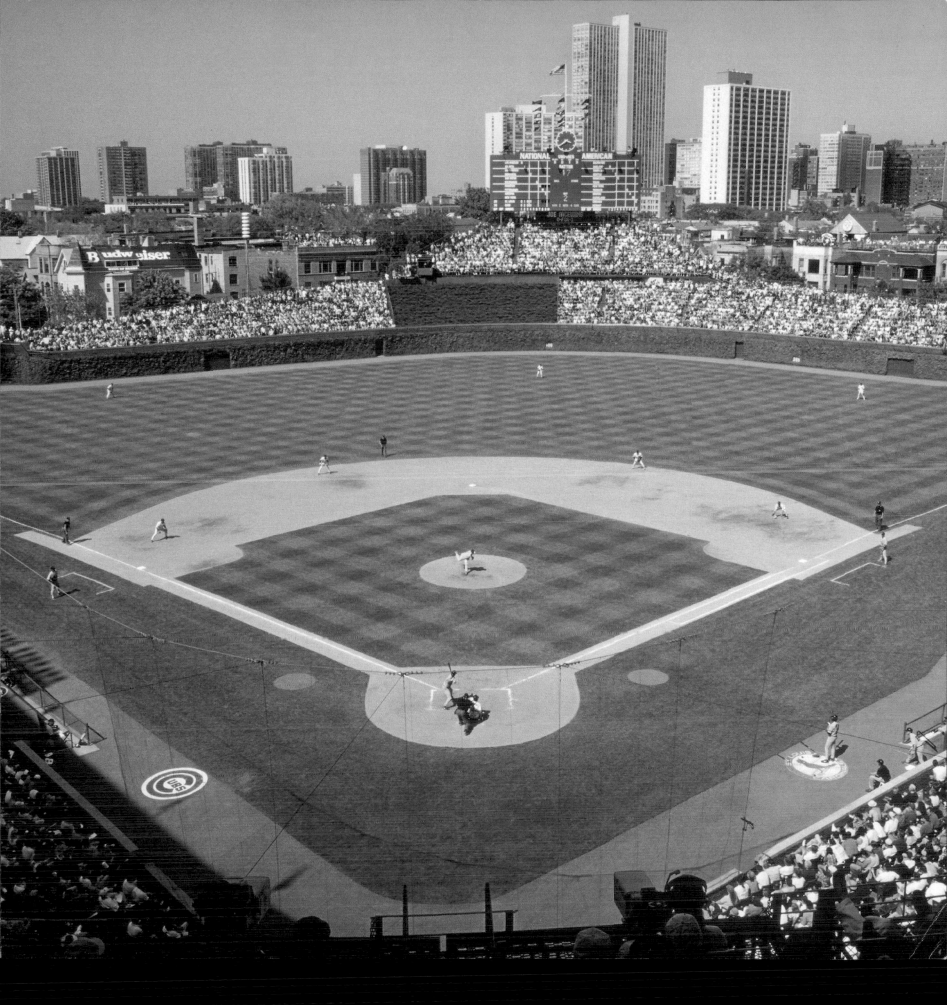

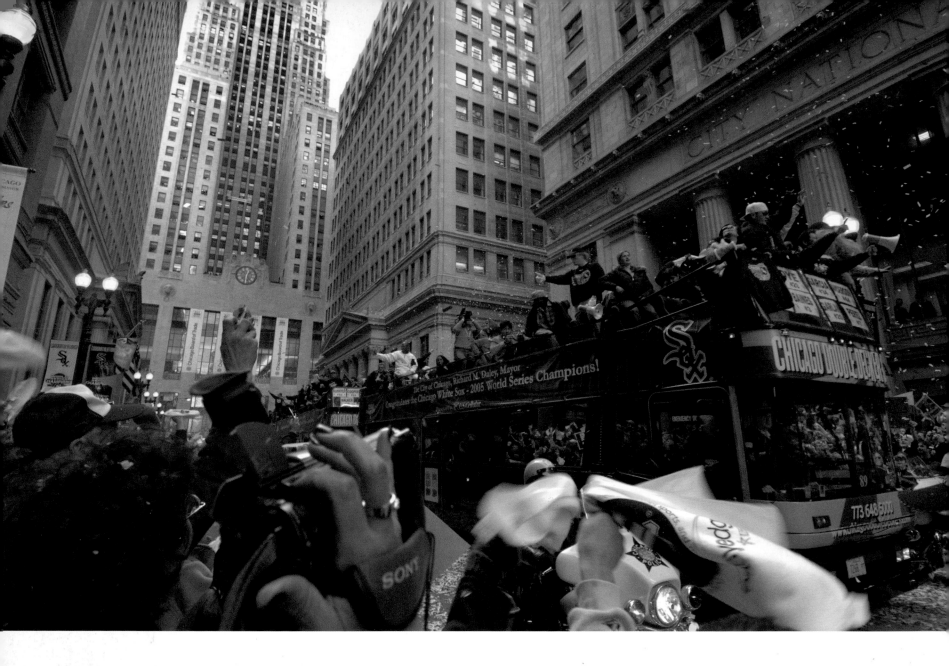

This riotous parade through downtown Chicago was held in 2005 to celebrate the White Sox winning the World Series for the third time.

OPPOSITE PAGE: One of Ivan Mestrovic's mounted warriors at the Congress Plaza entrance to Grant Park. In celebration of a White Sox victory, the horse's hooves have been appropriately adorned.

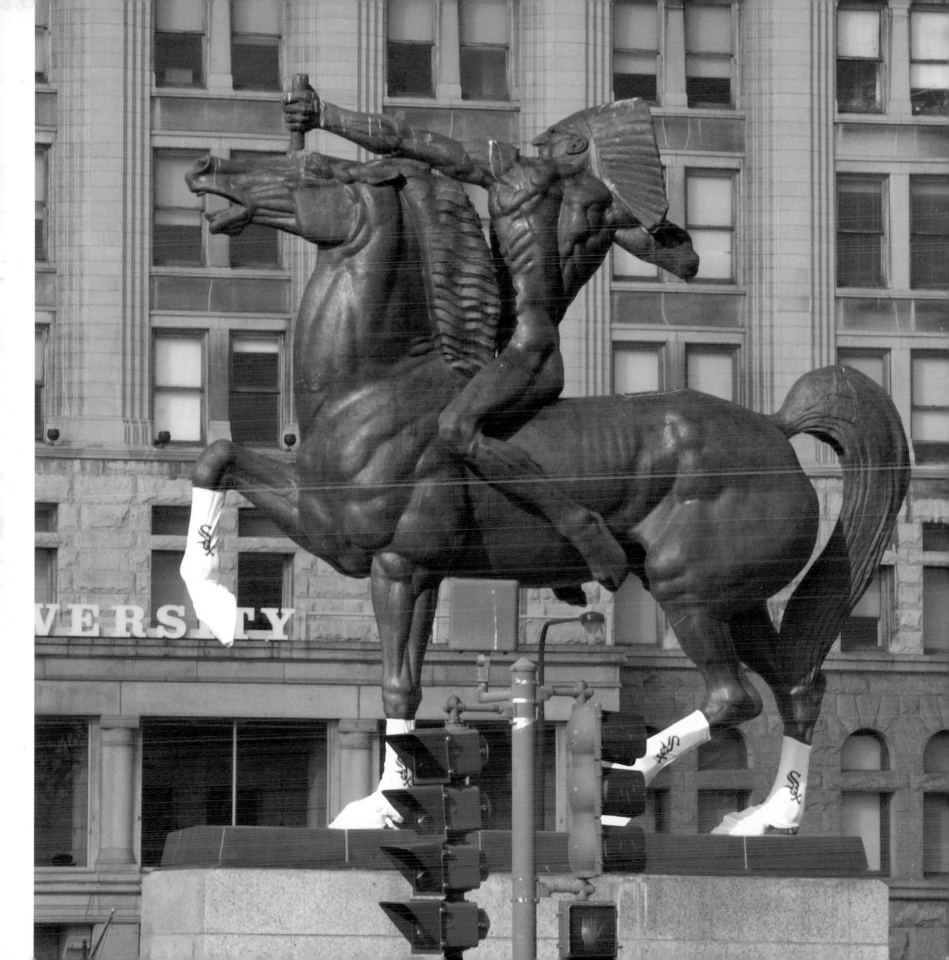

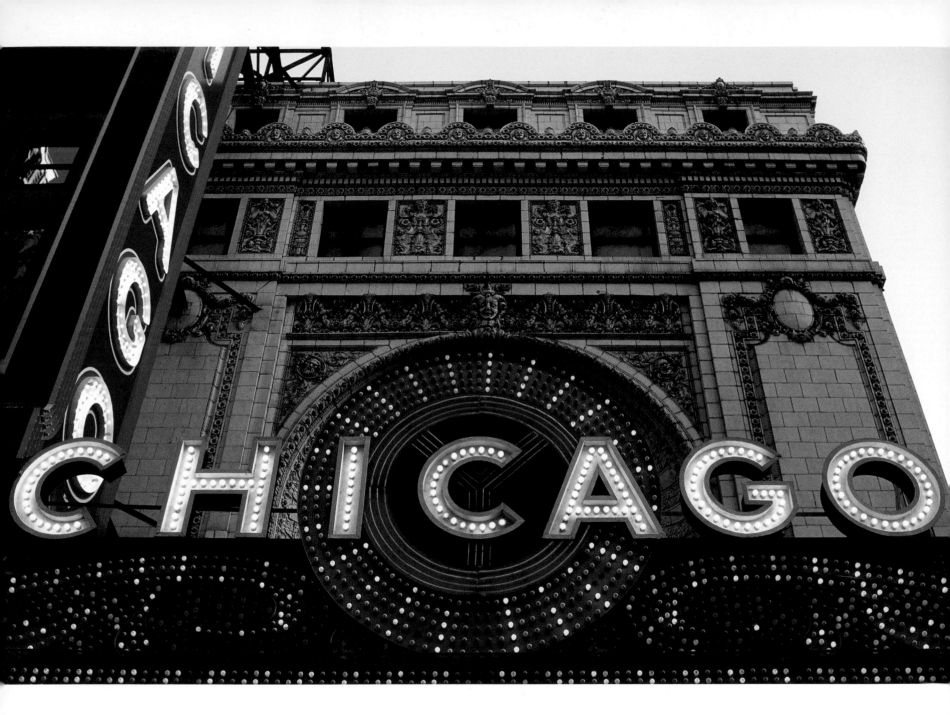

First opened in 1921 and considered to be the first lavish movie palace in the country, the legendary Chicago Theater has evolved to serve a variety of entertainment needs, from pop acts to stand-up comedy. The building and its famous illuminated signs have become one of the most recognizable sites on State Street.

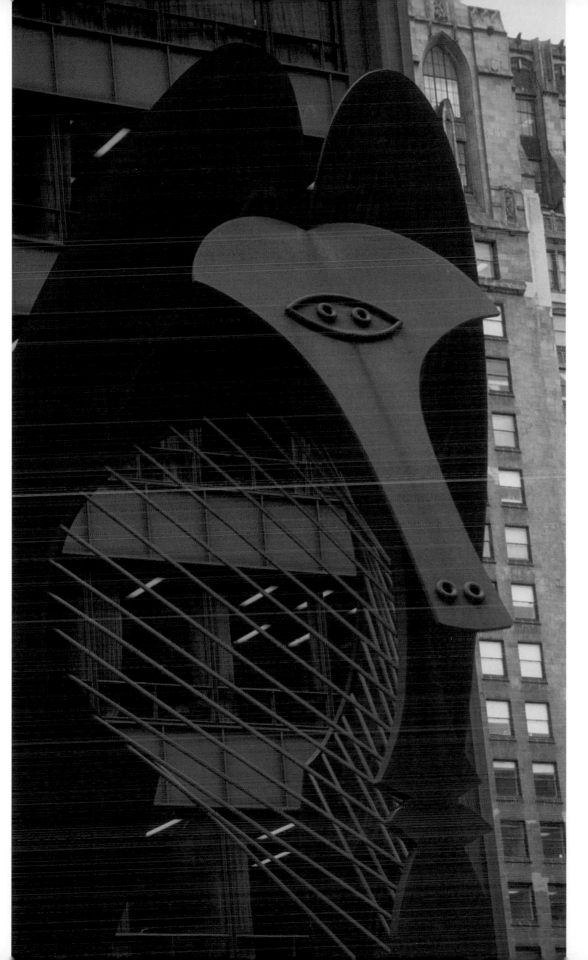

The design of the Chicago Picasso, as it is known, was finalized by the famous artist in 1966. Picasso made a gift of the piece, refusing to accept the $100,000 offered to him. Its true subject matter is hotly debated.

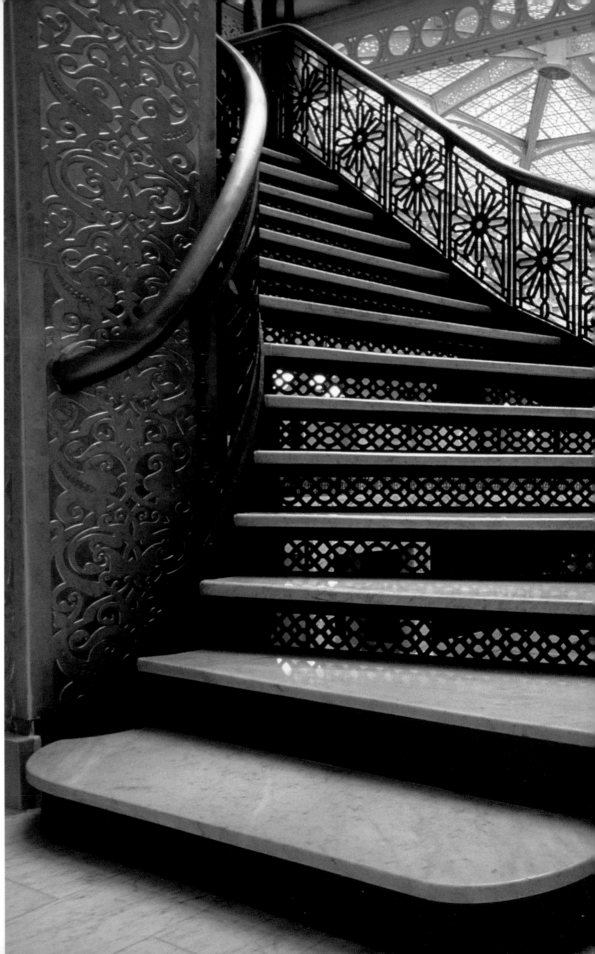

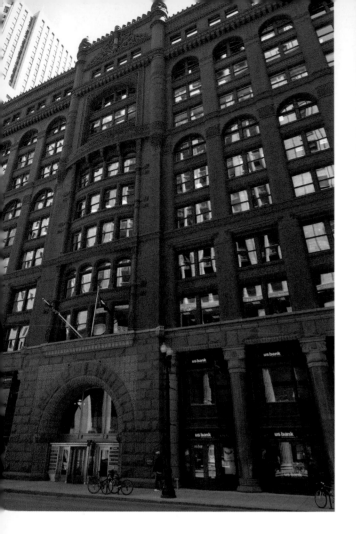

By observing the imposing Romanesque exterior of the Rookery Building, a visitor is unlikely to envision the light and airy interior allowed by the innovative use of iron framing.

OPPOSITE PAGE: The Rookery Building was built between 1885 and 1888. The interior lobby was remodeled by Frank Lloyd Wright in 1905.

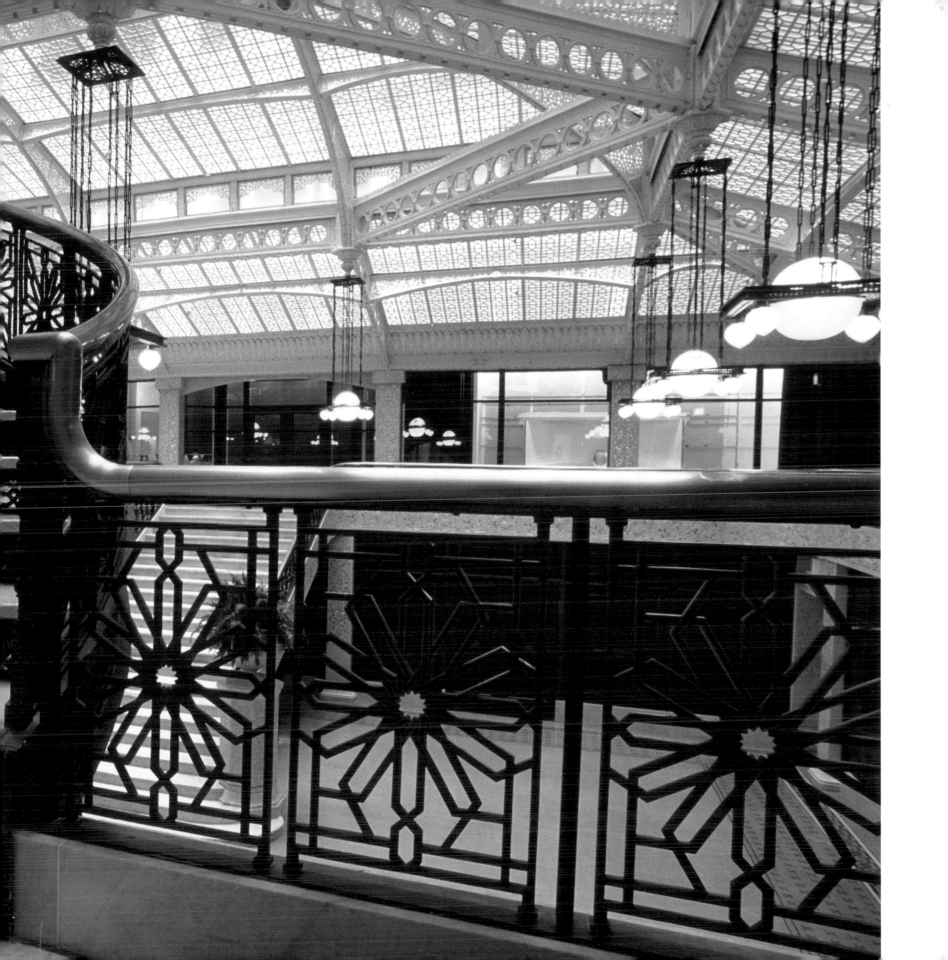

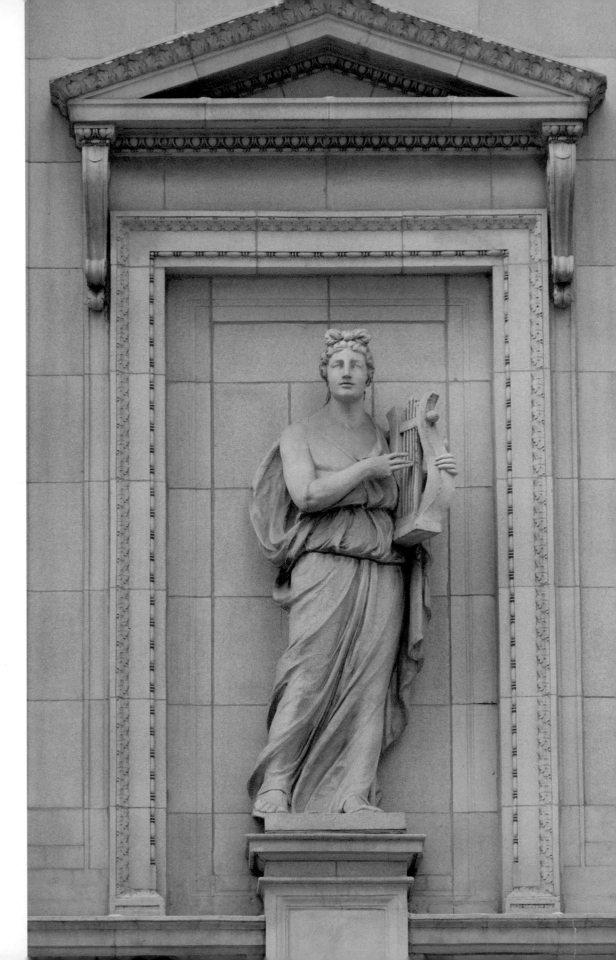

The Goodman Theater was established in 1925 and has been part of the Chicago art scene ever since. Elegant statuary adorns the outside of the structure.

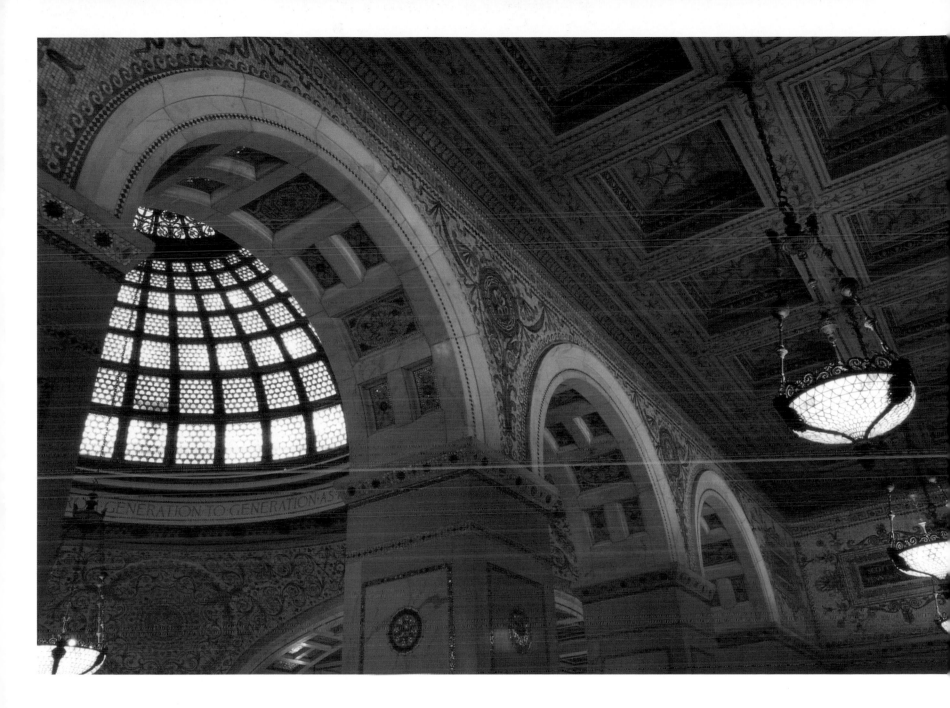

The centerpiece of the sumptuous decorations in the Chicago Cultural Center is the 38-foot-diameter Tiffany stained-glass dome in Preston Bradley Hall. The dome is believed to be the largest of its kind anywhere in the world.

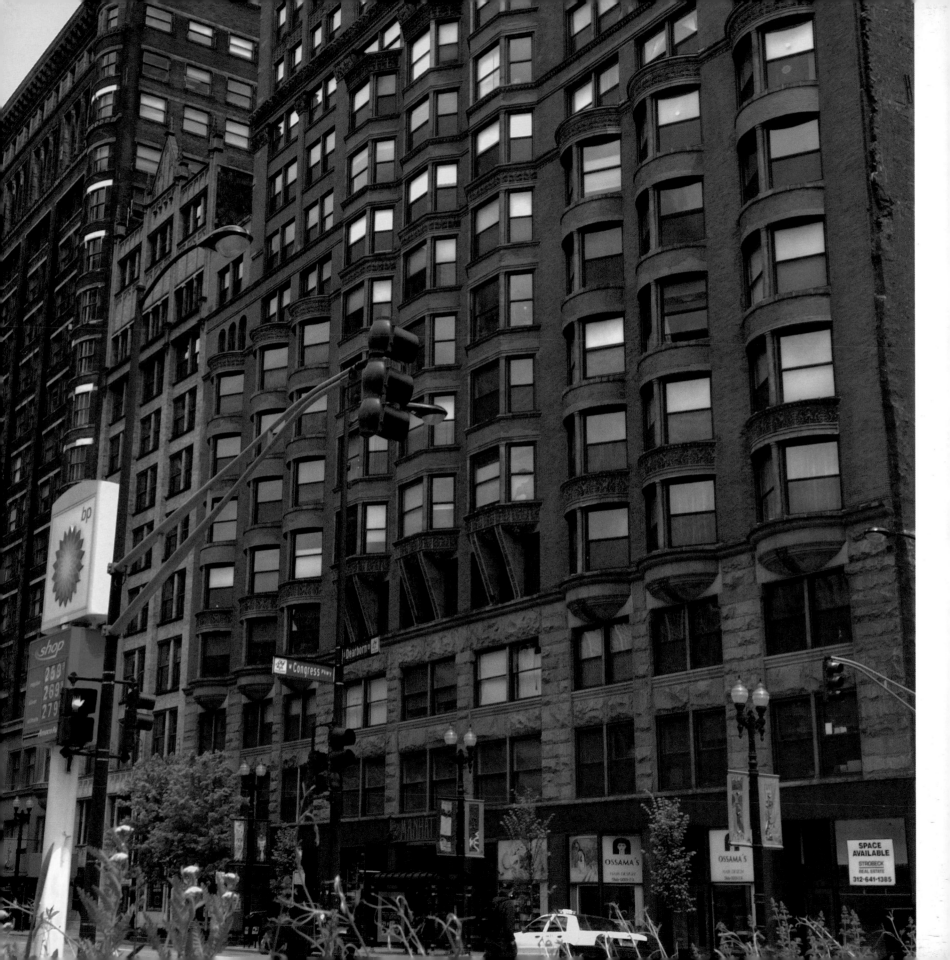

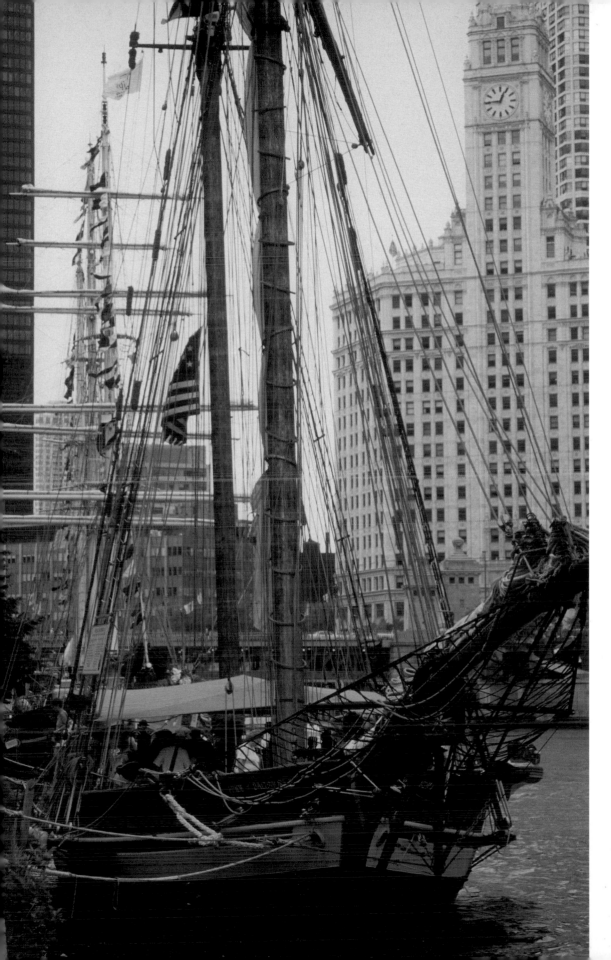

A tall ship is docked along the Chicago
River. Many such historical vessels take part
in celebrating the city's Great Lakes history.

OPPOSITE PAGE: The Manhattan Building on
South Dearborn Street, with its distinctive
bay windows, was built in 1891. The 16-story
skyscraper – remarkably tall for its time
– was considered an architectural wonder
by many visiting the city for the World's
Columbian Exposition two years later.

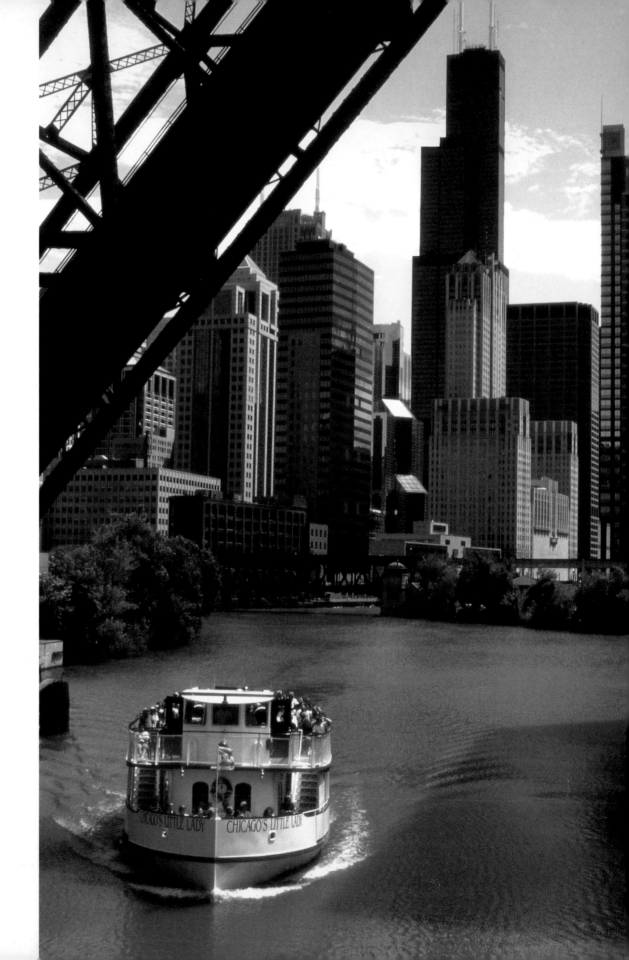

River cruises provide a unique perspective for appreciating Chicago's soaring towers and other architecturally significant sites.

OPPOSITE PAGE: The Beaux Arts Great Hall at Union Station is remarkable for its Corinthian columns, five-story barrel-vaulted atrium ceiling and marble floor. Union Station opened in 1925 and during World War II it handled as many as 100,000 people daily.

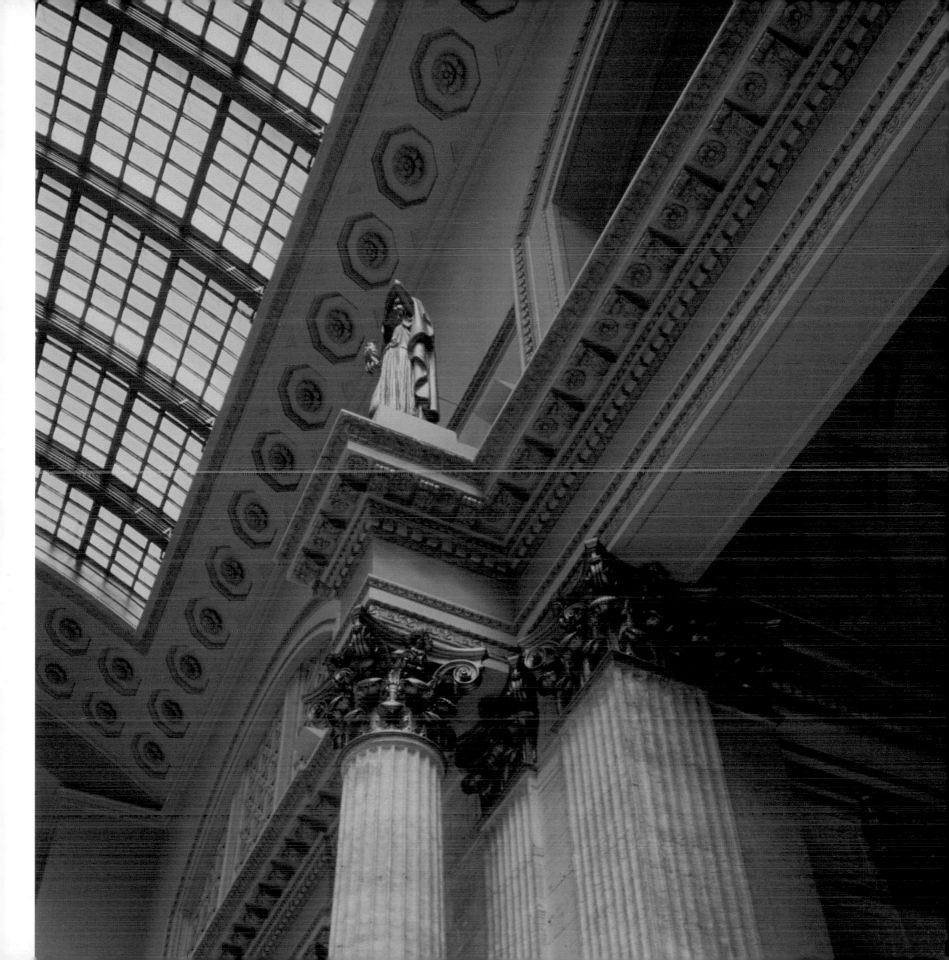

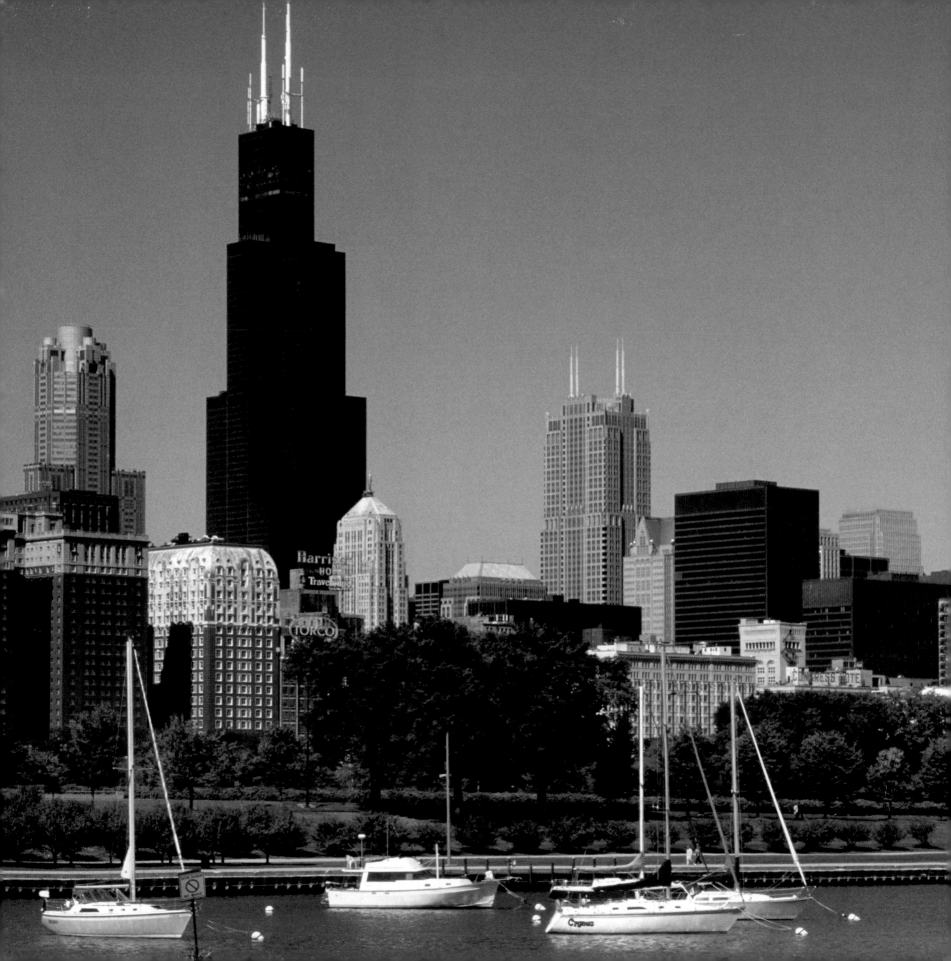

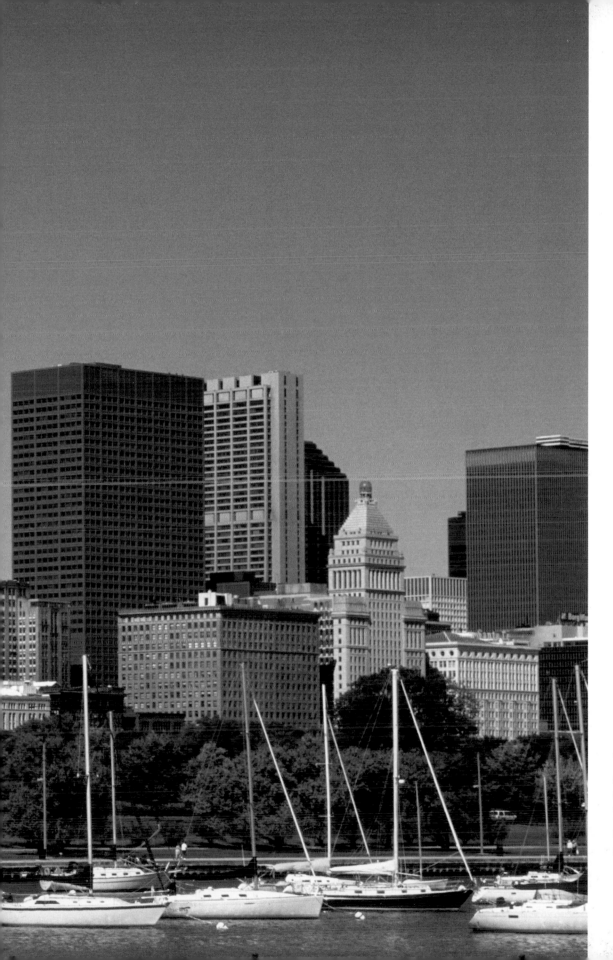

This is Monroe Harbor and Grant Park on a summer day as viewed from the peninsula that includes the Shedd Aquarium and Adler Planetarium. The Willis Tower dominates the skyline, which includes many buildings of the Loop and South Michigan Avenue.

Numerous bridges cross the Chicago River down Wacker Avenue. At least 35 movable bridges exist in the city.

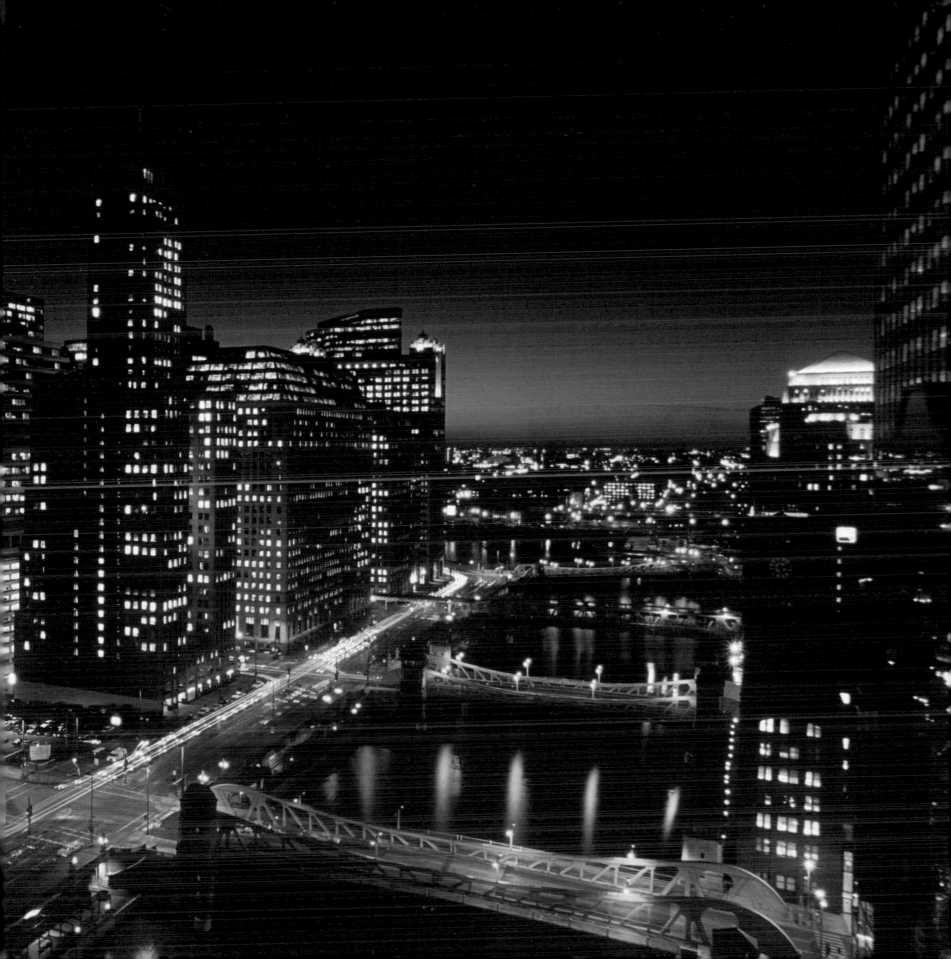

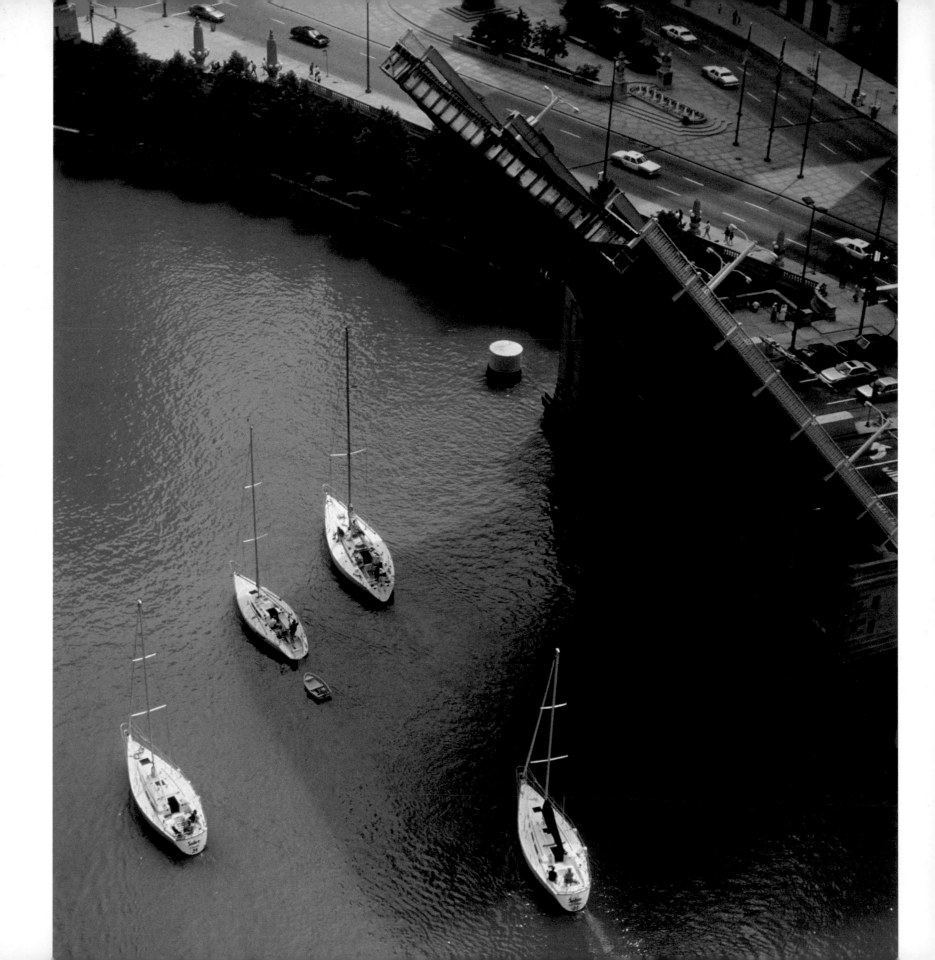

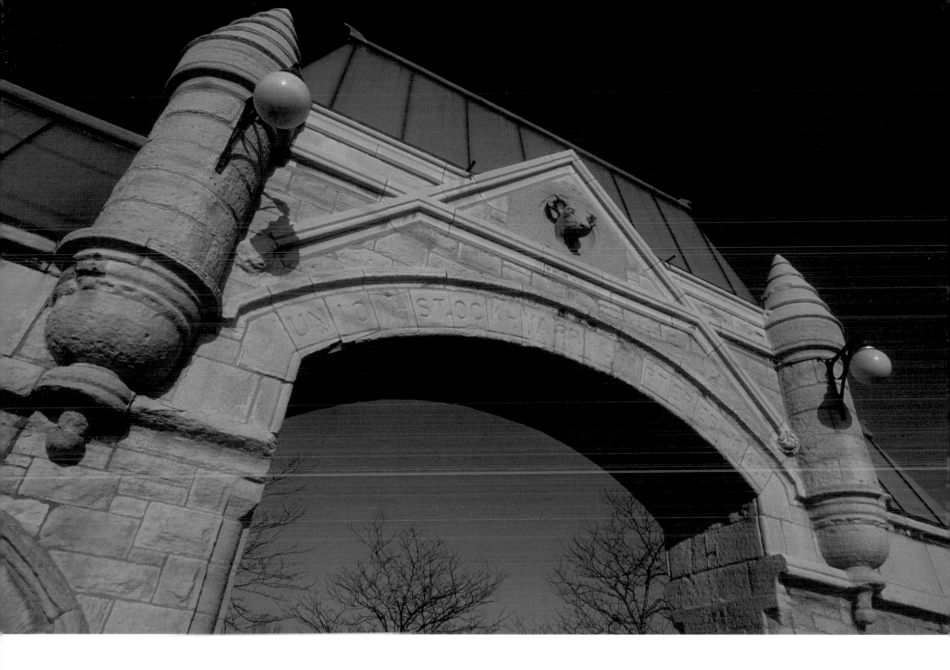

An elaborate gate with a sculpted head of a cow is all that remains of the once famous Union Stock Yards, which operated in Chicago for 106 years before closing in 1971. From the Civil War until the 1920s, more meat was processed here than anywhere else in the world.

OPPOSITE PAGE: An open drawbridge allows a fleet of sailboats access to Lake Michigan. There are numerous sailing and boating clubs within the city and its environs.

Swedish biologist Carl Linnaeus welcomes
visitors to the Midway Plaisance park of the
University of Chicago. The Gothic profile of
Harper Memorial Library rises in the rear.

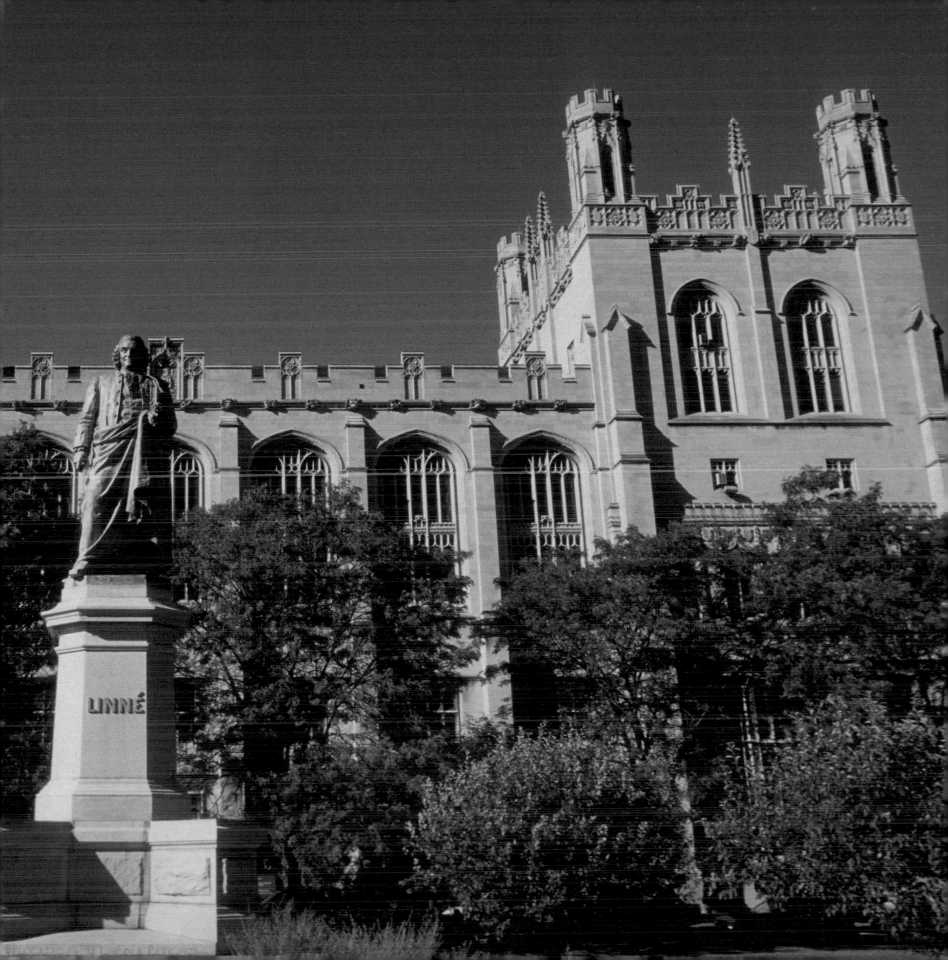

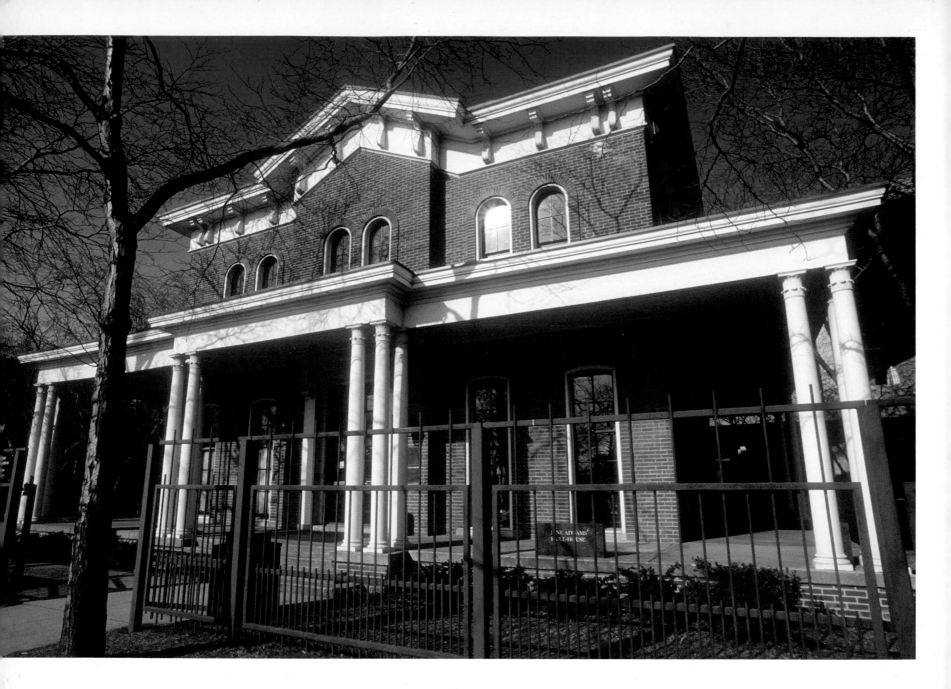

The restored Jane Addams Hull-House, located on the University of Illinois Chicago campus, was bought by its namesake in 1889 to serve as a base for her settlement house movement developed to aid new immigrants to America.

OPPOSITE PAGE: The Rockefeller Memorial Chapel, funded by oil magnate John D. Rockefeller, was dedicated in 1928. Designed by Bertram Goodhue in English Gothic style, the enormous limestone chapel features some of the largest stained-glass windows in the world.

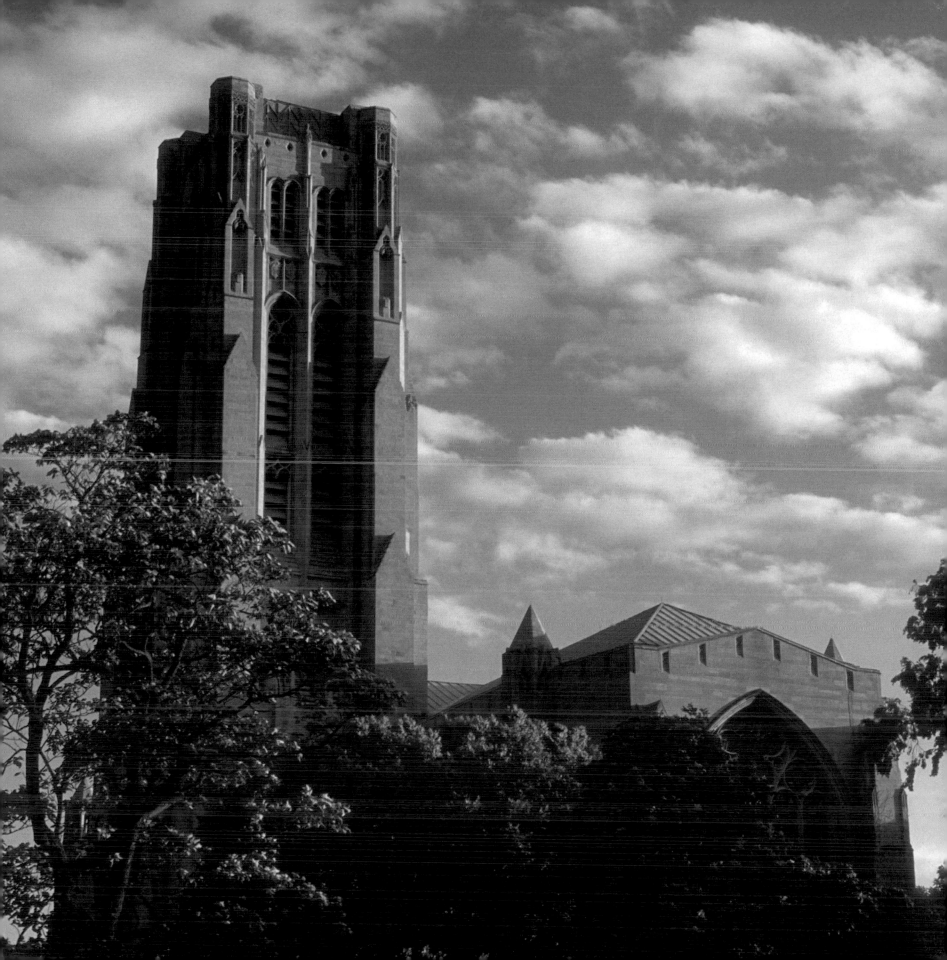

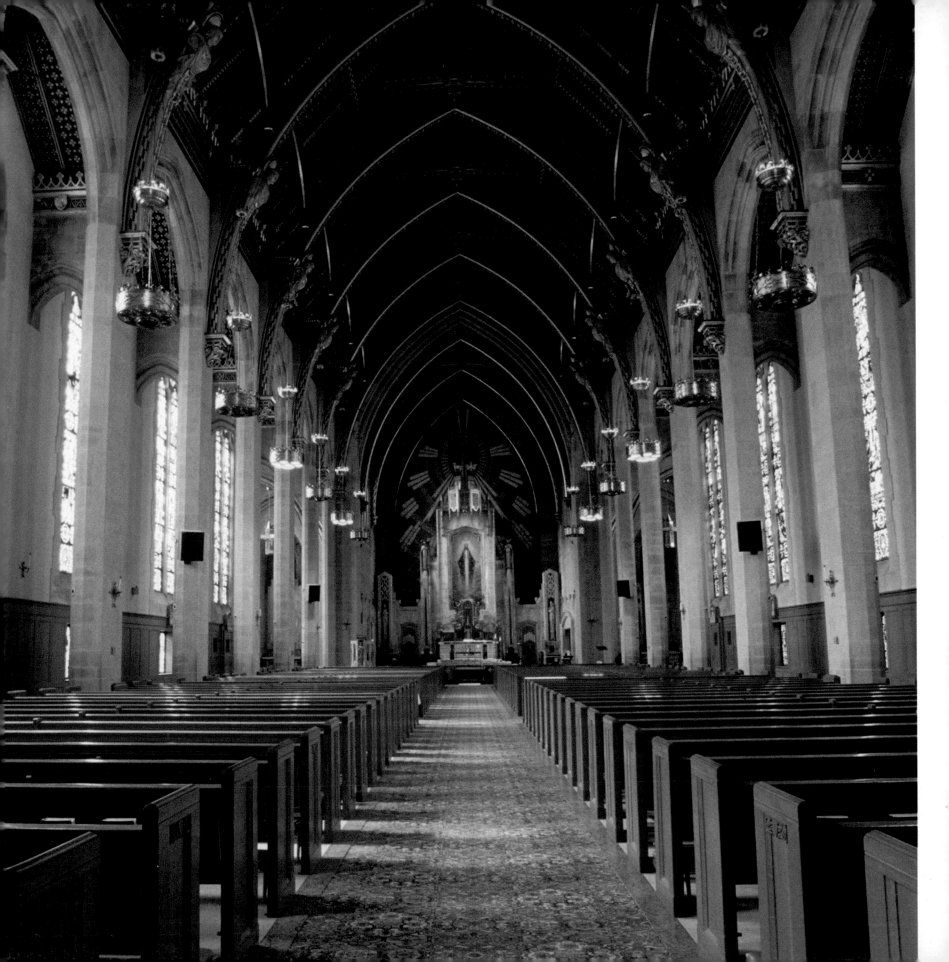

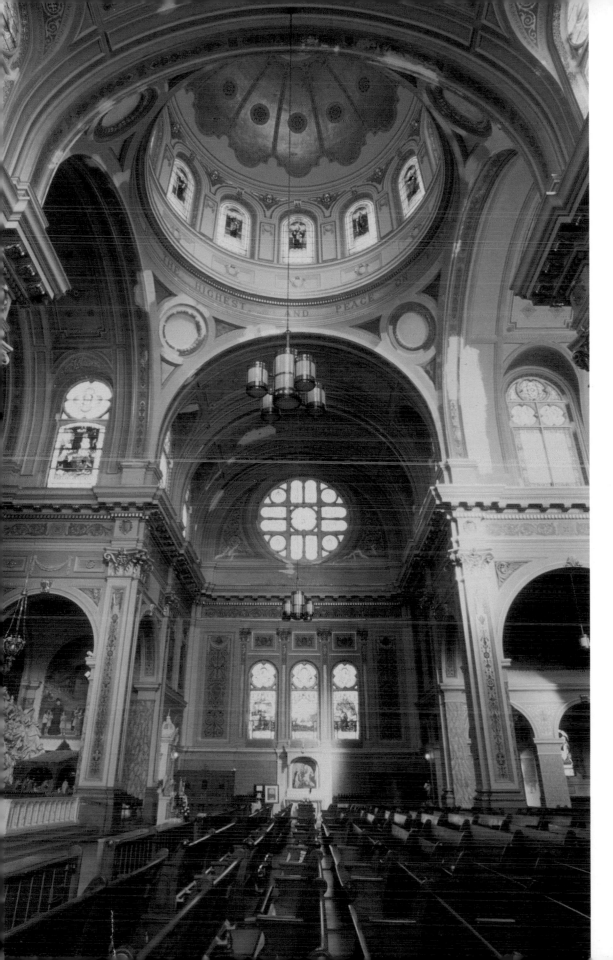

The opulent St. Mary of the Angels Church, opened in 1920, was slated for demolition in 1988. Thanks to the efforts of Joseph Cardinal Bernardin, the aging building was restored.

OPPOSITE PAGE: The magnificent Queen of All Saints Basilica is a church of cathedral size. Designed in a modern Gothic style, it was completed in 1960 and is located on the far North Side of Chicago.

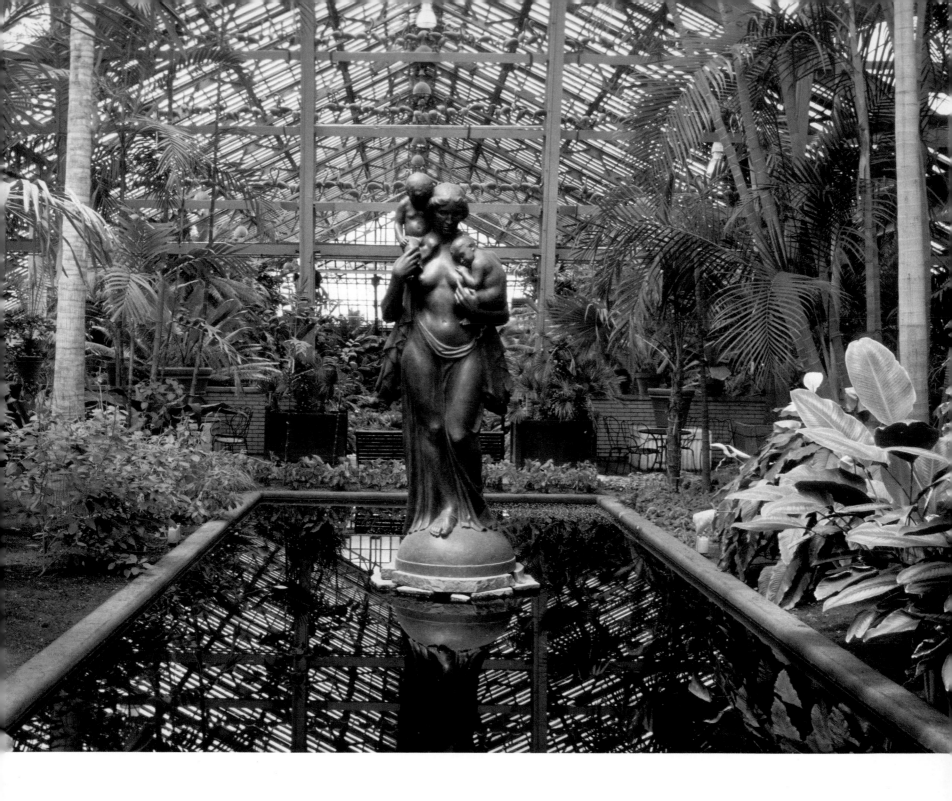

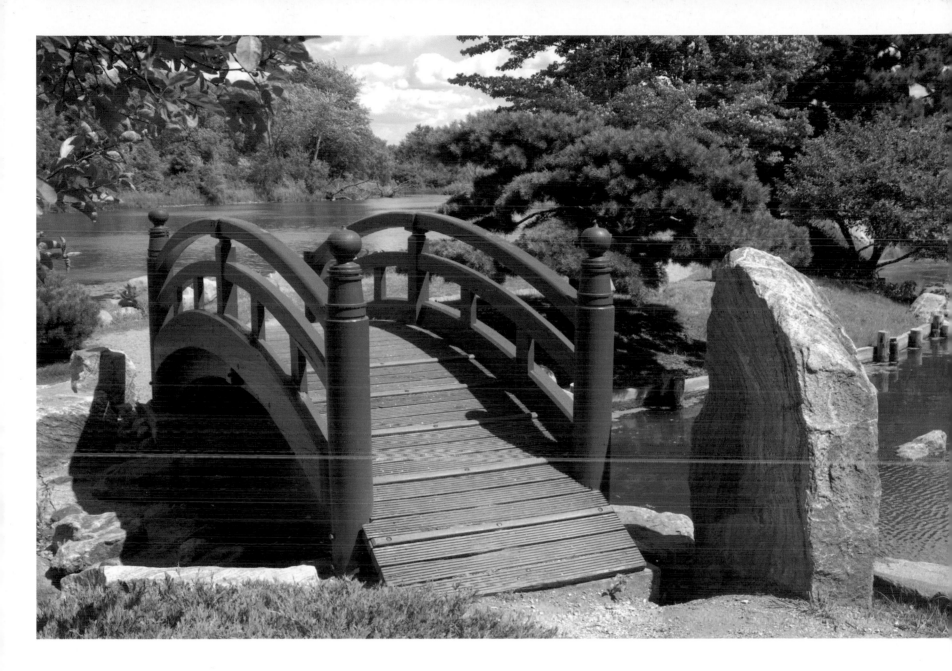

Osaka Japanese Garden in Hyde Park, one of the city's most diverse areas, provides an oasis of calm.

OPPOSITE PAGE: Garfield Park Conservatory, still one of the largest in the nation, was constructed between 1906 and 1907 and is fondly referred to as "landscape art under glass." The conservatory underwent a major restoration project that began in 1994. It continues to draw thousands of Chicagoans and visitors from all over the world.

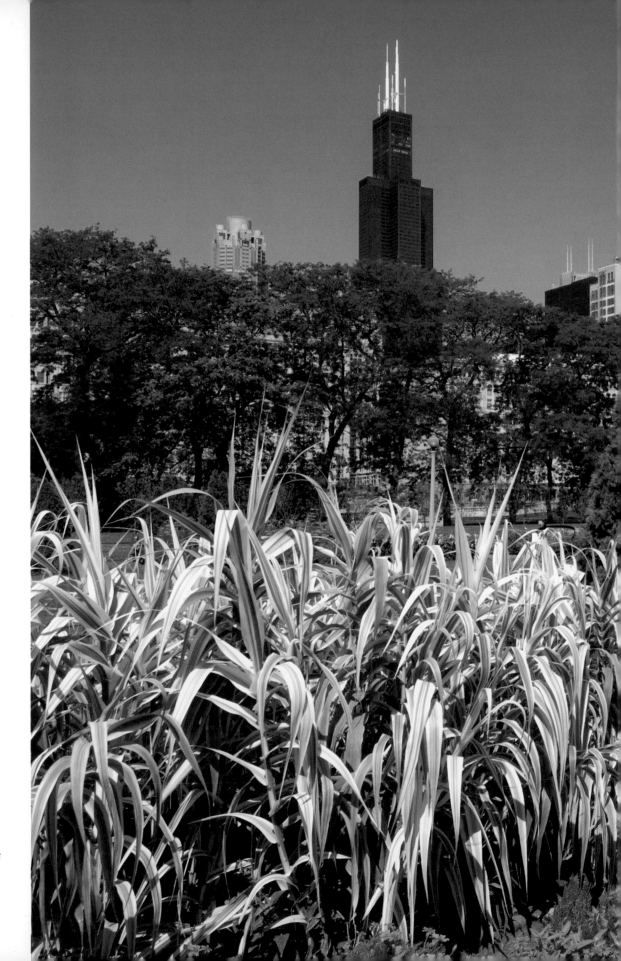

Grant Park is a 319-acre site that has been protected since the early 19th century. Besides the landscaped grounds along Lake Michigan, the park is also home to three of the city's most famous museums – the Art Institute, the Field Museum of Natural History and the Shedd Aquarium. Grant Park is also home to numerous summertime events.

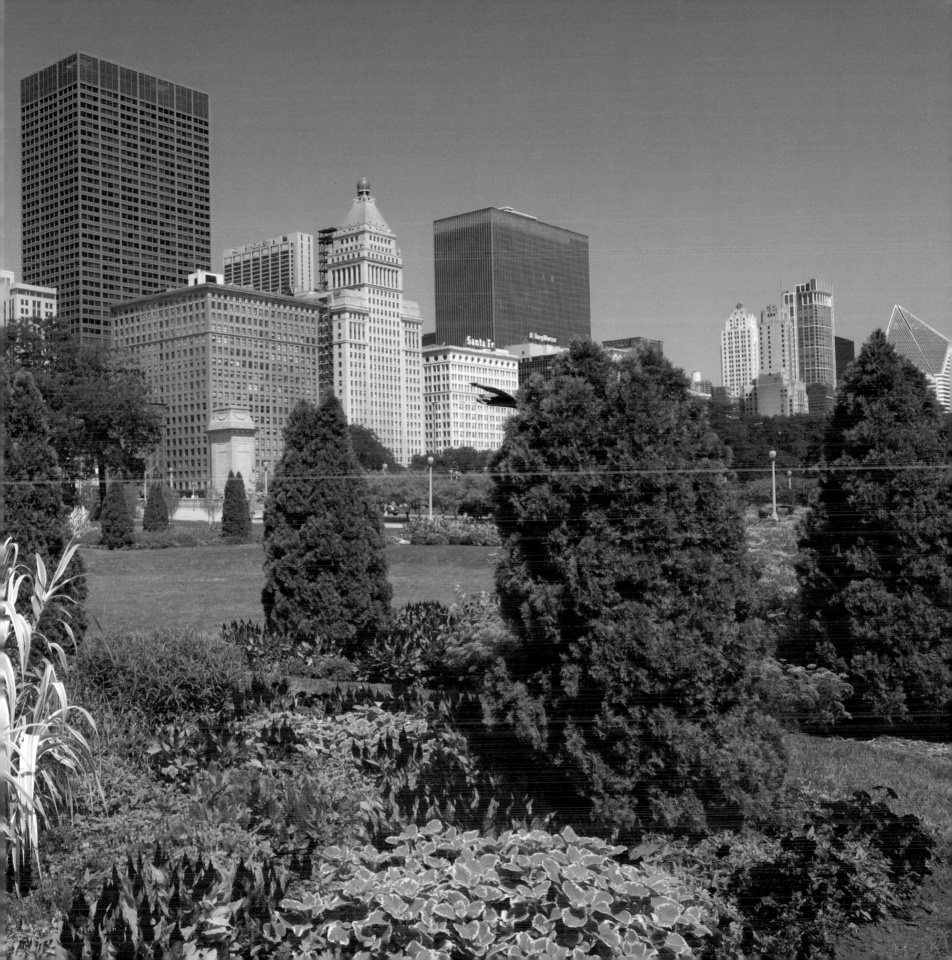

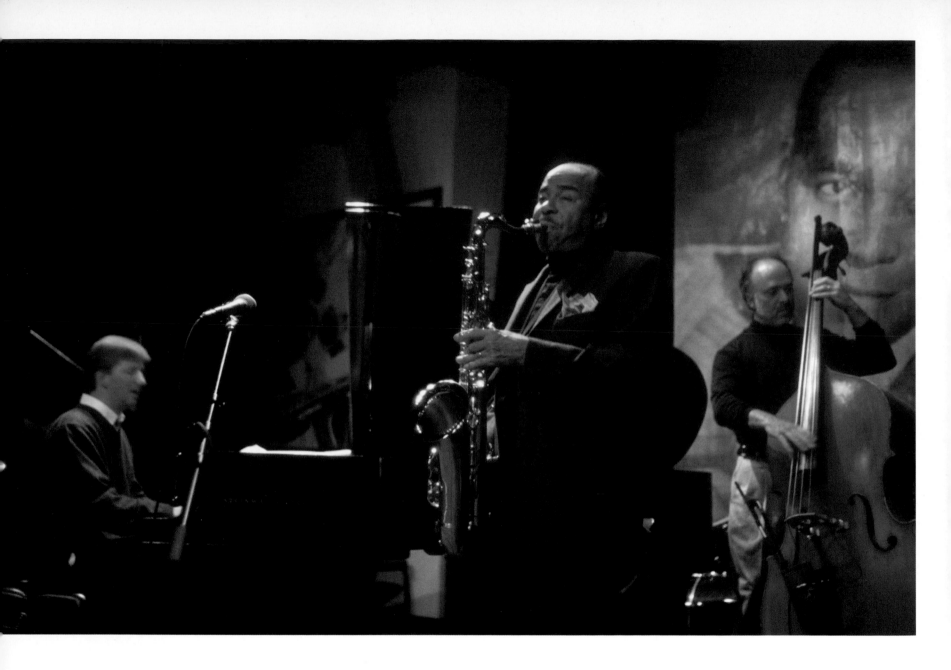

A group plays jazz in a Chicago club. The city is well known for its music scene. The Chicago Jazz Festival, held in Grant Park, draws as many as 100,000 people every year and is the world's largest free-admission jazz festival.

Blue Chicago on Clark is one of countless jazz and blues clubs in the city.

Founded in 1943, Pizzeria Uno claims to be the creator of Chicago's legendary deep-dish pizza. Also sometimes referred to as "stuffed," these famous pizzas feature a buttery crust and generous amounts of cheese, chunky tomato sauce and toppings.

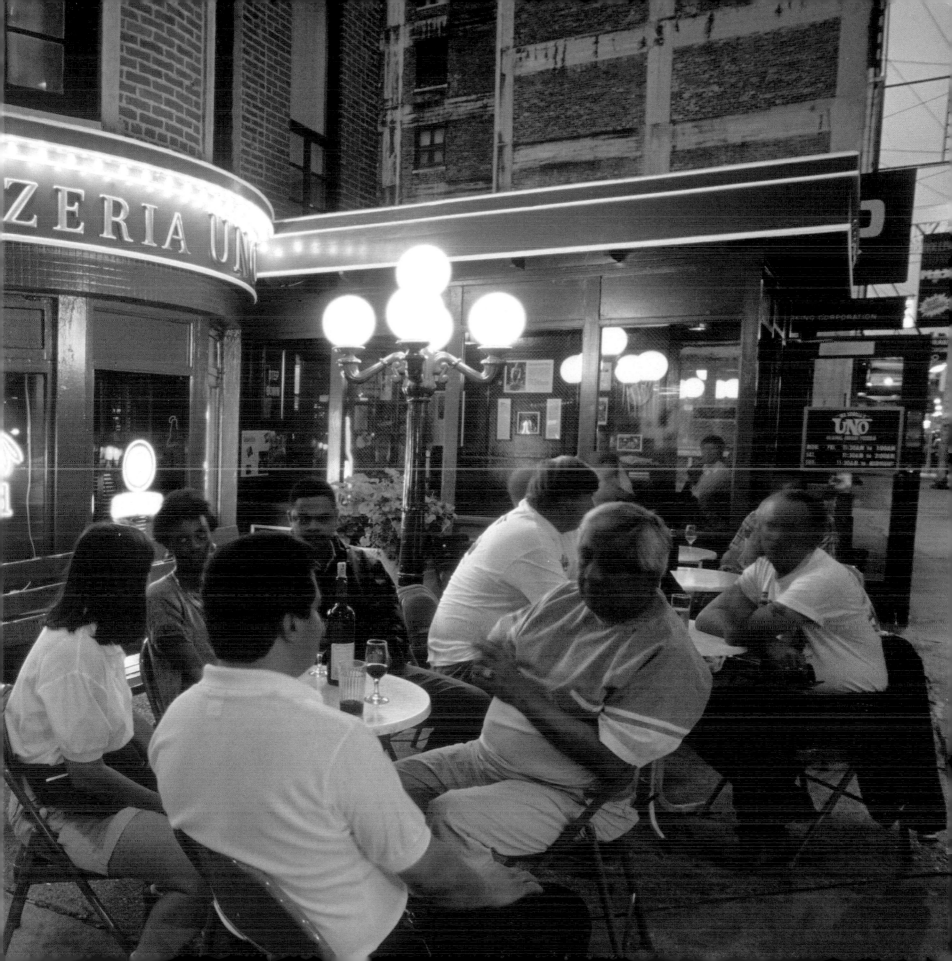

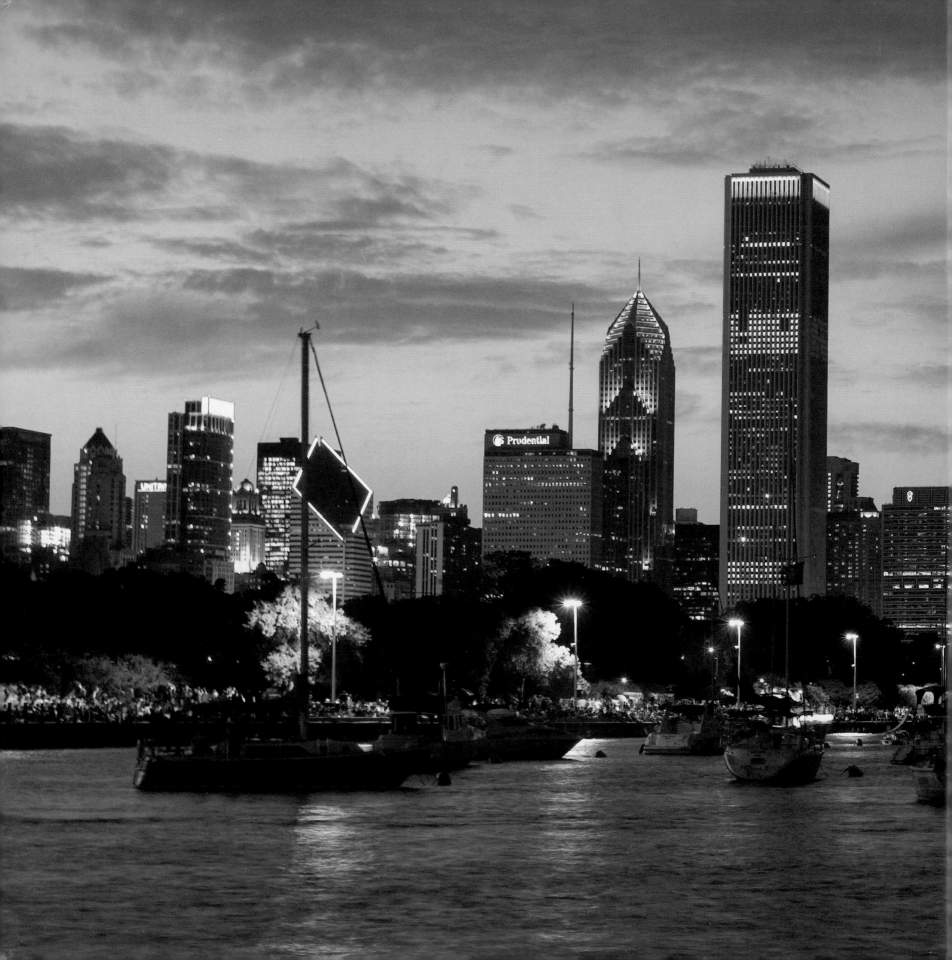

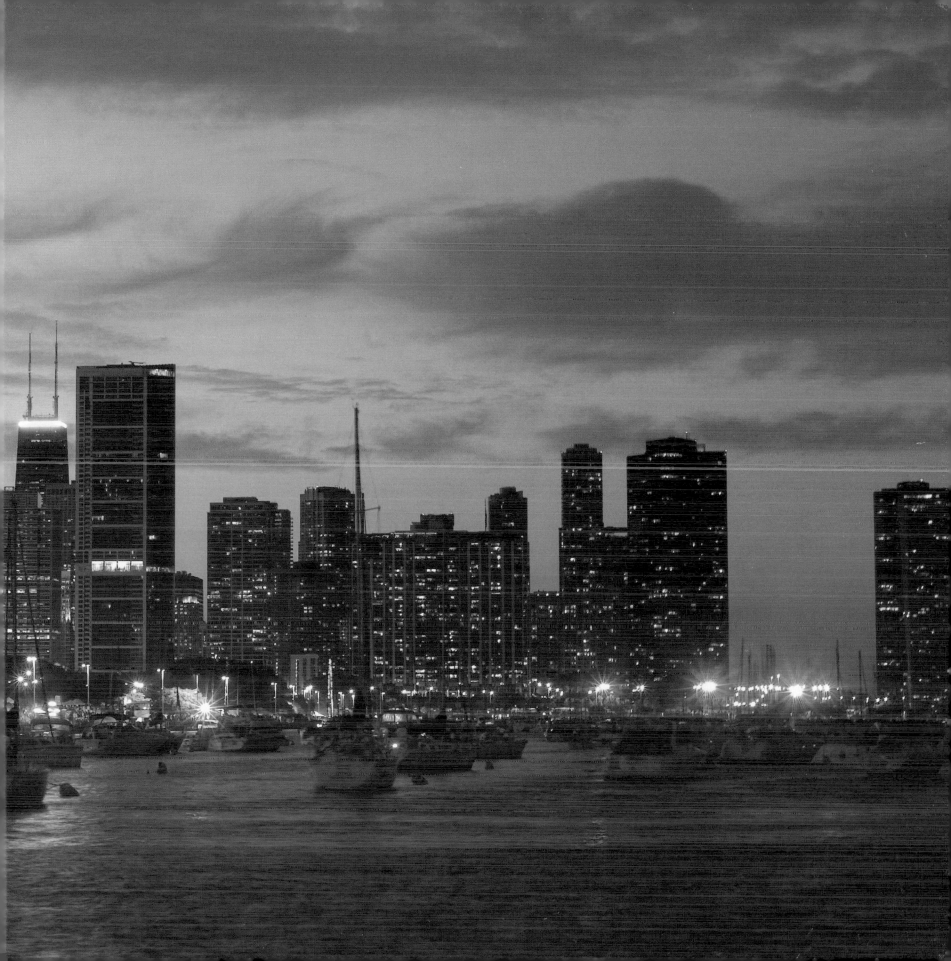

The sun sets over the Midway Plaisance in Hyde Park. The neighborhood is seven miles south of the Chicago Loop and home to the University of Chicago.

PREVIOUS PAGE: Venetian Night is an annual celebration featuring boats decorated with lights and props as they sail along in Monroe Harbor. Glowing Chicago skyscrapers serve as a backdrop to the show, which is capped off with an explosive fireworks display.

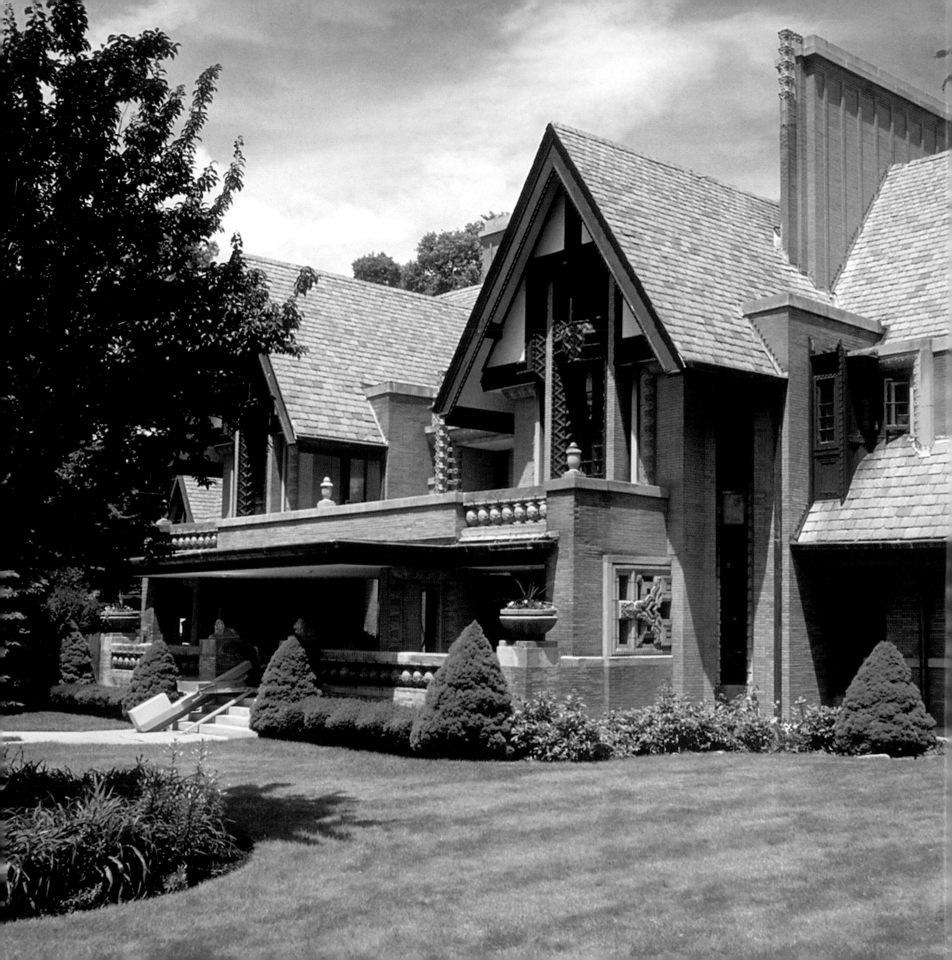

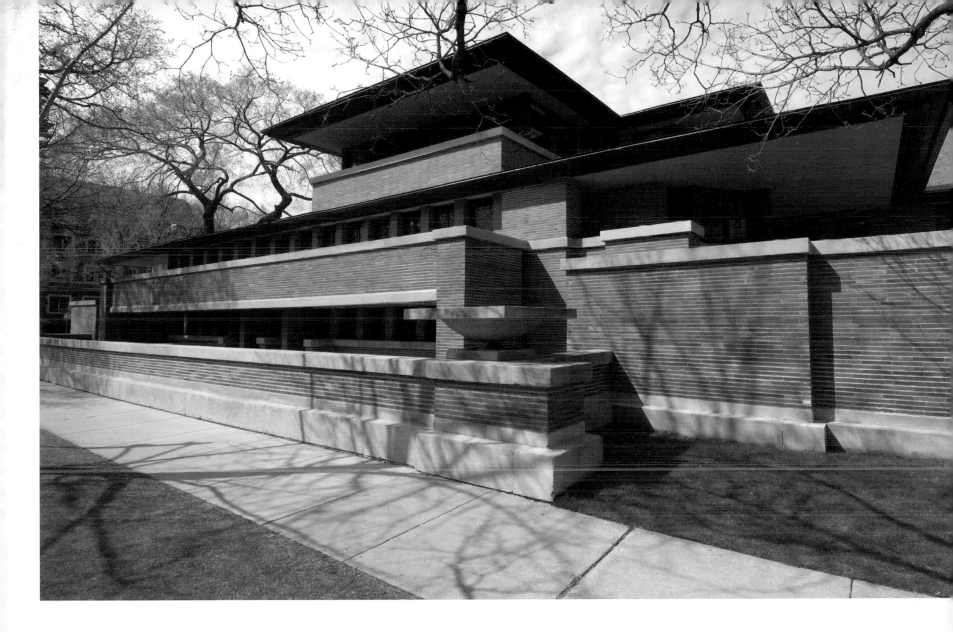

The home that Frank Lloyd Wright designed for Frederick C. Robie in 1908 has become one of the most famous structures of the 20th century. It expresses Wright's influential Prairie Style, marked by long, horizontal lines, dramatic overhangs and art glass windows.

OPPOSITE PAGE: The Nathan G. Moore House is one of the most famous of Frank Lloyd Wright's early designs. Completed in 1895 in the Tudor style, the structure was seriously damaged by fire in 1922, at which point Wright undertook its adaptation and restoration.

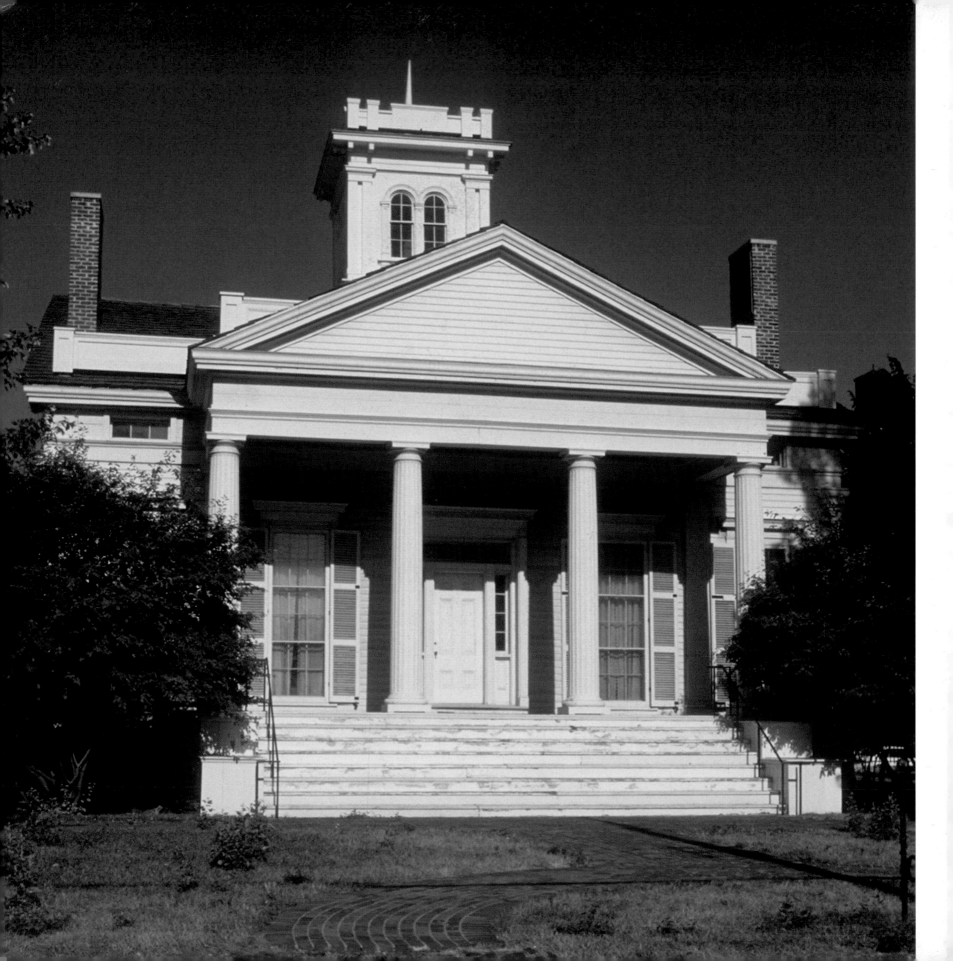

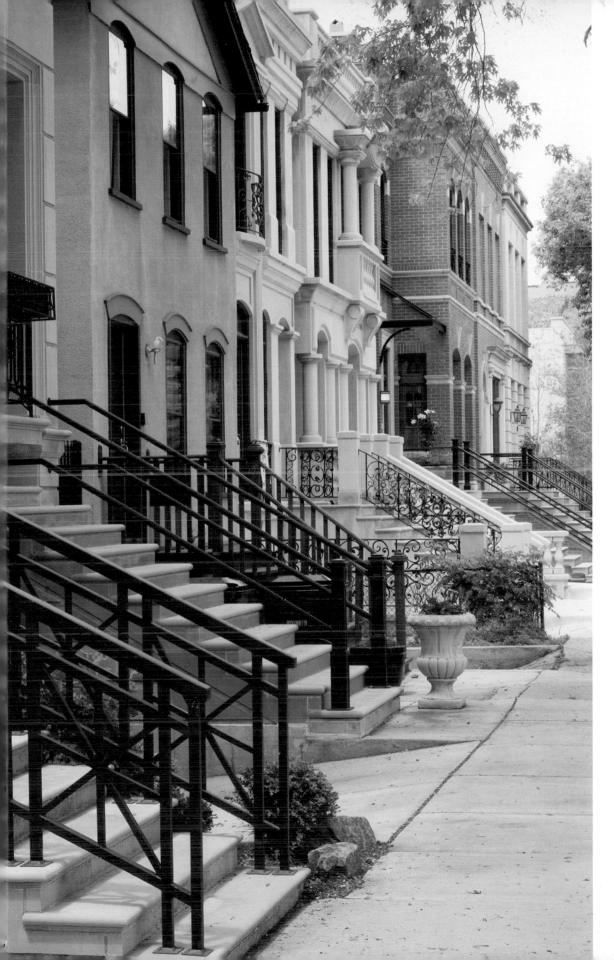

Lincoln Park is a North Side Chicago neighborhood well known for its historical churches, fashionable homes and upscale shops.

OPPOSITE PAGE: The Greek Revival Henry B. Clarke House, built for a wealthy hardware dealer in 1836, is considered the city's oldest structure.

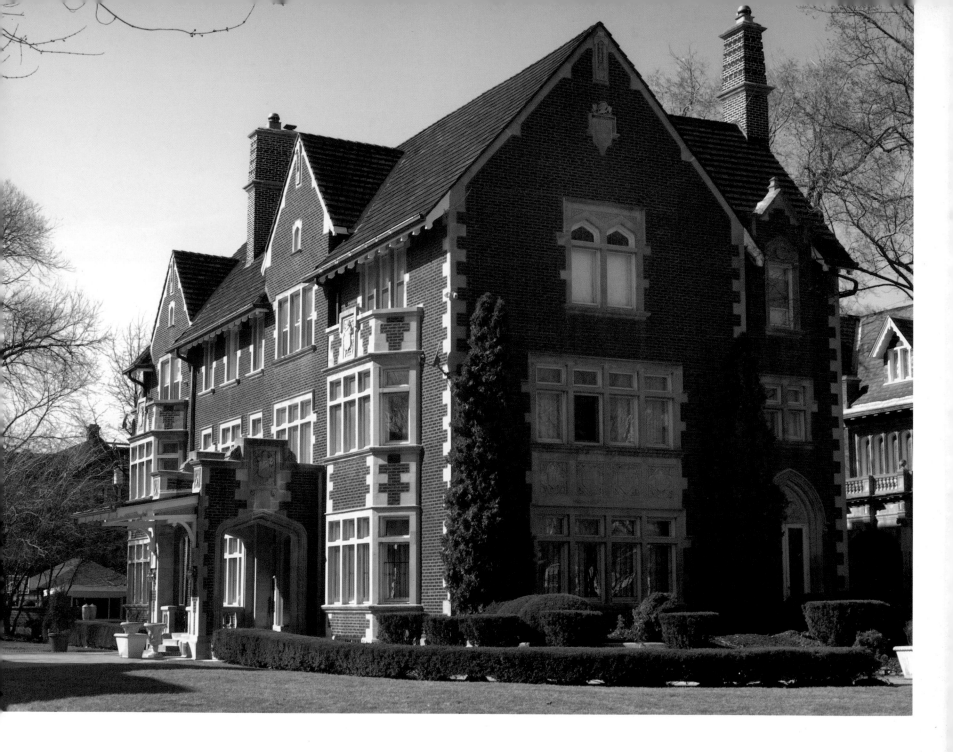

The exclusive Kenwood neighborhood, on the South Side of Chicago, contains some of the city's most opulent homes, like this brick mansion. Other Kenwood residences include the Obama house.

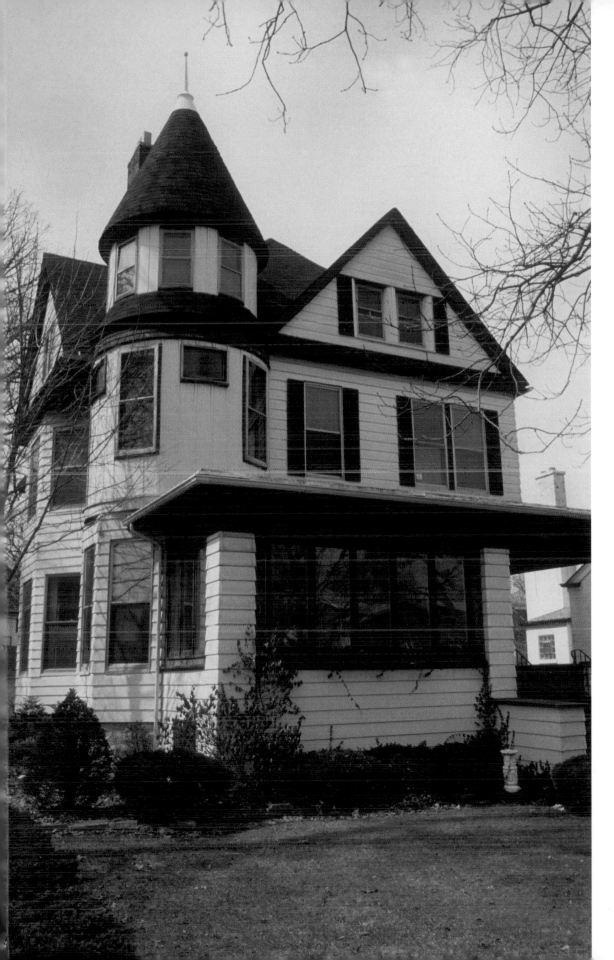

The Ernest Hemingway Birthplace Home is where the author was born on July 21, 1899. The Queen Anne house has been completely restored and is furnished as it would have been at the turn of the 19th century.

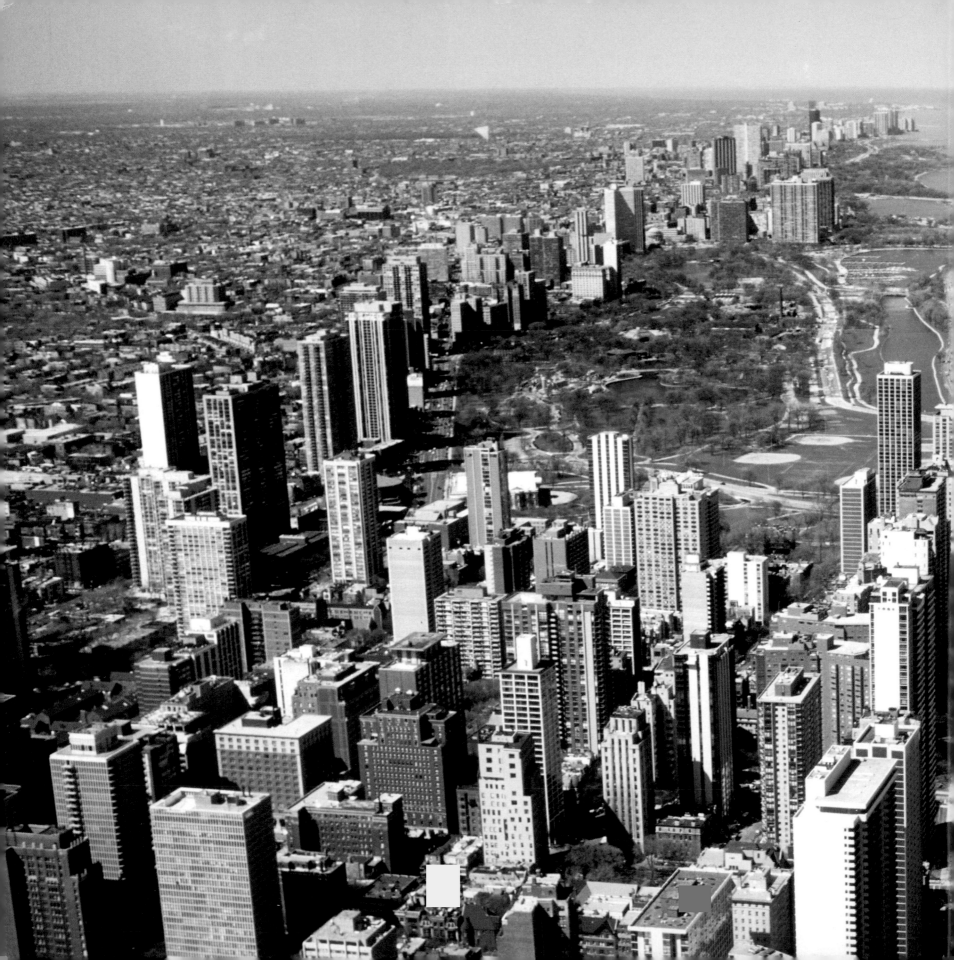

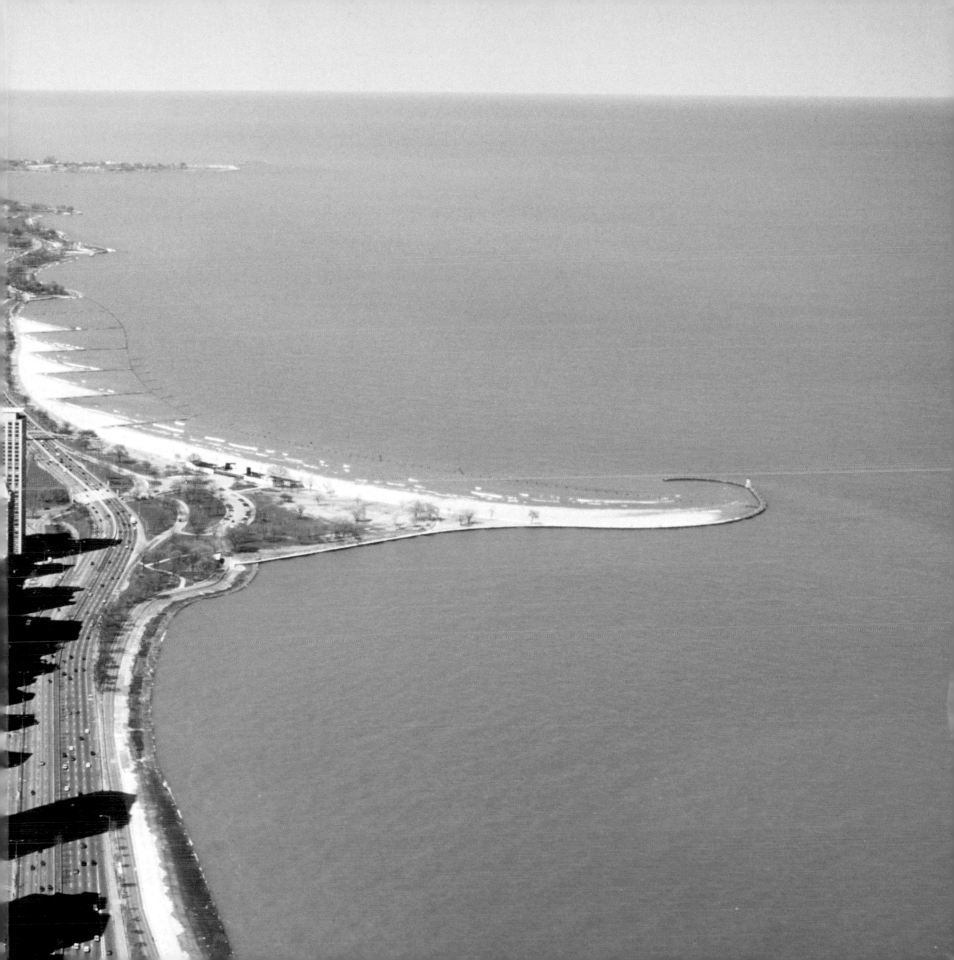

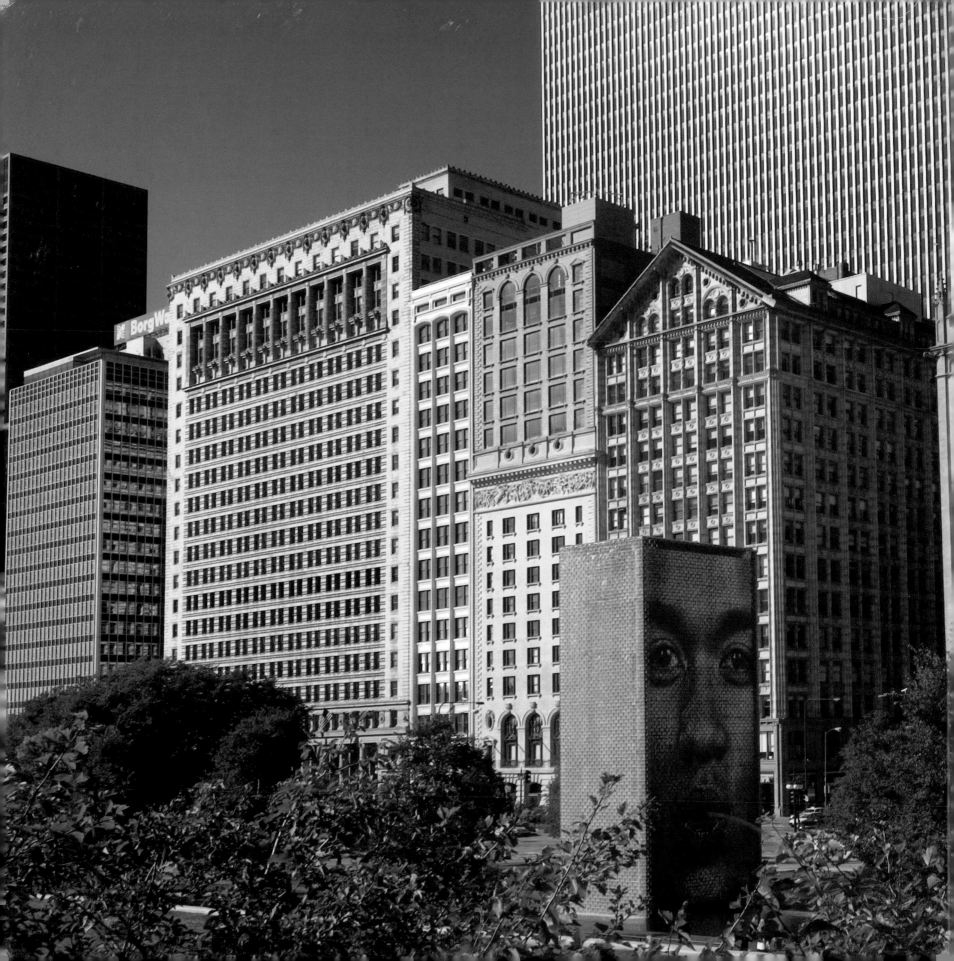

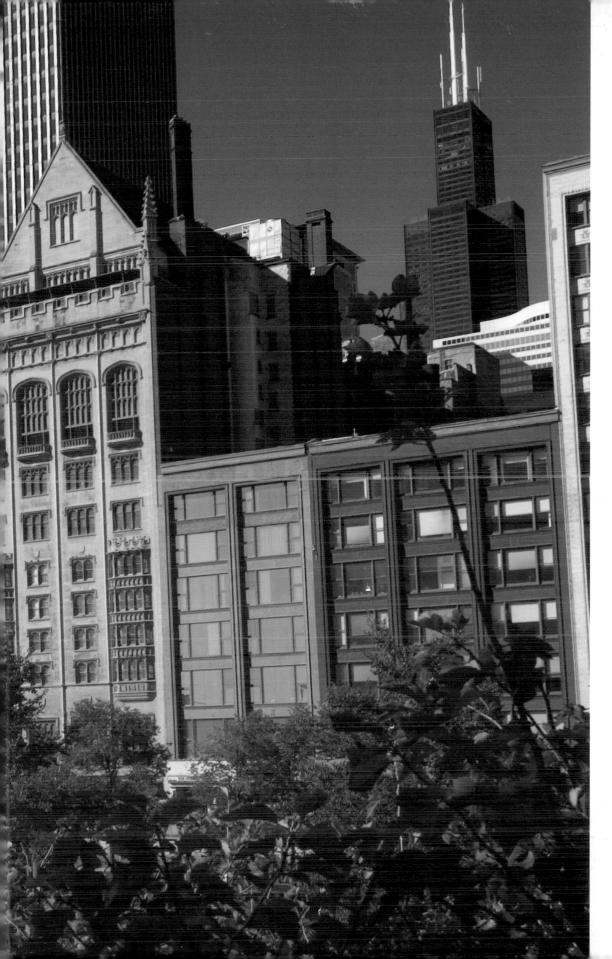

This stretch of South Michigan Avenue across from Millennium Park stands as one of the world's most-recognized streets. The 12-block stretch of historic buildings – some dating back to the 1880s – is an outdoor museum of the work of the city's best architects. This "streetwall" was designated a Chicago Landmark in 2002, and the facades of the buildings cannot be changed without city approval. Crown Fountain in the foreground has faces of hundreds of people that rotate on a giant video screen. Every few minutes, water shoots out of a mouth.

PREVIOUS PAGE: One can often catch an extraordinary view of Chicago and Lake Michigan from the John Hancock Observatory on the 94th floor. Lake Michigan is said to define the city.